SHARED
VISIONS

Native American Painters
and Sculptors in
the Twentieth Century

Margaret Archuleta and Dr. Rennard Strickland

Essays by

Joy L. Gritton

W. Jackson Rushing

THE NEW PRESS

NEW YORK

Cover Art: PATRICK DesJARLAIT (Chippewa) *Gathering Wild Rice*
c. 1971 water color on paper 27.8×39.5 cm.

Published in the United States by The New Press, New York
Distributed by W.W. Norton & Company, Inc.
500 Fifth Avenue, New York, NY 10110

Library of Congress Cataloging-in-Publication Data

Shared visions : Native American painters and sculptors in the twentieth century / edited by
Margaret Archuleta and Rennard Strickland. —2nd ed.
p. cm.
Rev. ed. of: Shared visions / Margaret Archuleta and Rennard Strickland.
Catalog of an exhibition held at the Heard Museum, Phoenix, Ariz., Apr.–May 1991.
Includes bibliographical references.
ISBN 1-56584-069-0
1. Art, Indian—Exhibitions. 2. Art, Modern—20th century–United States—
Exhibitions. 3. Indians of North America—Art—Exhibitions. I. Archuleta, Margaret.
II. Strickland, Rennard. III. Archuleta, Margaret. Shared visions. IV. Heard Museum.
N6538.A4A7 1993
704'.0397'0904–dc20 95-50853
 CIP

First New Press Edition.
Originally published by The Heard Museum.

Established in 1990 as a major alternative to the large, commercial publishing houses, The New
Press is intended to be the first full-scale nonprofit American book publisher outside of the
university presses. The Press is operated editorially in the public interest, rather than for
private gain; it is committed to publishing in innovative ways works of educational, cultural, and
community value, which, despite their intellectual merits, might not normally be "commercially
viable."

SHARED VISIONS: Native American Painters and Sculptors in the Twentieth Century, the exhibition upon which this catalogue is based, premiered at The Heard Museum, Phoenix, Arizona, on April 13, 1991. After closing on July 28, 1991, a national tour to the following venues was scheduled:

> The Eiteljorg Museum of American History and Western Art, Indianapolis, Indiana
> The Thomas Gilcrease Institute of American History and Art, Tulsa, Oklahoma
> The Oregon Art Institute, Portland Art Museum, Portland, Oregon
> The National Museum of the American Indian, Smithsonian Institution, The U.S. Custom House, New York, New York

The exhibition was organized by Margaret Archuleta, Curator of Fine Art, The Heard Museum, and Dr. Rennard Strickland, Director, The American Indian Law Center, University of Oklahoma, Norman. The exhibition was designed by Patrick Neary. Exhibit assistance was provided by Gina Cavallo, Tony Fleming, Lisa MacCollum, David Ortega, and Kevin Winters.

In conjunction with the opening of *SHARED VISIONS*, a conference sponsored by the Rockefeller Foundation was scheduled to be held at The Heard Museum, May 8-11, 1991.

The catalogue, *SHARED VISIONS*, was designed by Lisa MacCollum and David Ortega. Editorial assistance was provided by Mary H. Brennan, Carolyn Grove, and Ann Marshall. The Reader for the catalogue was Dr. Lucinda Gedeon, Chief Curator, University Art Museum, Arizona State University, Tempe, Arizona. Research assistance was provided by Fran Dameron, Rowena Dickerson, and Johnathan Yorba. Clerical assistance was provided by Geraldine Cavanaugh and Angeline Hopkins.

All *SHARED VISIONS* photography, unless otherwise noted, was done by Craig Smith, Tempe, Arizona.

Dimensions of all works of art are listed in centimeters or meters, by height, width, and depth.

SHARED VISIONS has been made possible through a grant from The Flinn Foundation. The national tour of *SHARED VISIONS* is being sponsored by AT&T.

Additional funding and support for the exhibition have been provided by the Edna Rider Whiteman Foundation, AG Communication Systems, and KTSP-TV 10/CBS.

THE HEARD MUSEUM
22 East Monte Vista Road
Phoenix, Arizona 85004-1480

SHARED VISIONS: Native American Painters and Sculptors in the Twentieth Century is a project that was conceived both in celebration and in sadness. It celebrates a generous gift to The Heard Museum of the Rennard Strickland Collection of Fine Art. Dr. Strickland is a distinguished legal scholar and active member of the Museum's National Advisory Board. A number of works from the Strickland Collection is being shared with the public in this exhibition.

There is also an element of sadness to the project, in that so many important artists of Native American heritage have yet to be acknowledged by historians and critics of American fine art. By bringing together a visually stunning and emotionally powerful assemblage of works by these artists, we hope that the Native American Fine Art Movement will gain wider understanding and appreciation.

It is fitting that The Heard Museum should undertake such a project. For three decades, the Museum has maintained a commitment to collect, exhibit, and interpret painting and sculpture by Native American artists from throughout North America. More recently, we launched a series of Biennials that brings fresh, new work to the attention of scholars, artists, and our visitors. Recognizing a related need, The Heard Museum Library and Archives has established a Native American Artists Resource Collection that includes files on more than 7,000 individuals, documenting their careers and achievements.

Three people deserve special recognition for making *SHARED VISIONS* a reality. Dr. Rennard Strickland launched the idea of a comprehensive exhibition drawn from many major collections, as a means of summing up the importance of the extraordinary, but widely neglected, Native American Fine Art Movement. His informed and acute understanding of that movement is evident in the essay that appears in this catalogue, and in the depth and scope of the collection that he has gifted to The Heard Museum. My immediate predecessor and good friend, Michael J. Fox, was prescient in seeing the significance of this project, and energetic and persuasive in securing the resources to make it happen. Margaret Archuleta, our Curator of Fine Art, carried the organizational responsibilities from start to finish. Her professionalism and deep personal identification with the people and issues of *SHARED VISIONS* were the project's greatest assets.

On behalf of the Board of Trustees of The Heard Museum, I extend warm thanks to Rennard, Mike, and Margaret, and to all of my colleagues on the Museum staff who worked so capably to attend to the thousands of details. Thanks too to all the partners who have been so generous to us: the collaborating museums, lenders, funders, and, above all, the artists whose work is represented in *SHARED VISIONS*.

Martin Sullivan, Ph.D.
Director
The Heard Museum
Phoenix, Arizona

The Smithsonian Institution's National Museum of the American Indian is delighted to join with The Heard Museum in this celebration of the painting and sculpture of the Native American. *SHARED VISIONS: Native American Painters and Sculptors in the Twentieth Century* has provided an opportunity for our new museum to begin fulfilling one of its major goals of sharing the Native American heritage with as large a national audience as possible. We are pleased to have loaned a number of our treasures for this exhibition of The Heard Museum, which will also be the initial fine arts exhibit at the National Museum of The American Indian's New York City site, the U.S. Custom House.

SHARED VISIONS brings together the "best of the best" – many of the finest paintings and sculpture of master artists of the Native American Fine Art Movement. The works come not only from The Heard Museum's superb Native American fine arts collection, but from private individuals, other major museums, and government collections. The significance of *SHARED VISIONS* is that it shows, in depth, the range of achievement of American Indian professional artists creating work which, as Oscar Howe noted, "can compete with any art in the world."

The exhibition is, to me, a touching personal experience, not only because it displays the work of artists, such as my father and many of his contemporaries and his students, but because it contains "The Intruders," a watercolor by my high school classmate Jerome Tiger that the Museum of the American Indian purchased before, but received after, his untimely death in 1967. Furthermore, the impetus for *SHARED VISIONS* was the gift to The Heard Museum of the Indian fine arts collection assembled by another of my high school colleagues, Rennard Strickland. The works had been collected by Dr. Strickland with the support and guidance of our teacher Jack Gregory.

SHARED VISIONS contains not just historic works, but also contemporary painting and sculpture, illustrating one of the central themes of both the National Museum of the American Indian and The Heard Museum – Native American culture is a living part of our ongoing civilization. Indeed, these twentieth century Indian artists help us understand that which is unique and special in this changing world as we move toward the twenty-first century.

W. Richard West, Jr.
Director
National Museum of the
American Indian
Smithsonian Institution
Washington, D.C.

THE WAY PEOPLE WERE MEANT TO LIVE: THE SHARED VISIONS OF TWENTIETH CENTURY NATIVE AMERICAN PAINTERS AND SCULPTORS

by Dr. Rennard Strickland and Margaret Archuleta

When we first sat down on the Reservation, the Agents and those who directed them in Washington expected all the Arapaho men to become farmers But the Arapaho had always lived in bands, with their tipis side by side, their horses grazing together, and with hunting and feasting and worship all carried on by the group. It took years to learn to settle down on a farm and work alone and see one's neighbors only once in awhile. Neither we nor our dogs nor our ponies understood this way of white people. To us it seemed unsociable and lonely, and not the way people were meant to live.

Carl Sweezy, *The Arapaho Way*[1]

SHARED VISIONS exhibits the works of major artists of the twentieth century Native American Fine Art Movement. Emphasis is placed upon artists who helped to shape the movement and whose work influenced the direction of American Indian painting and sculpture. Individual works were selected to represent the depth and diversity of Native American art and artists. Art works range from the early narrative paintings of Carl Sweezy (Arapaho, 1881-1953) and Ernest Spybuck (Shawnee, 1883-1949), to a series of works on the topic of "encounter and response" executed in 1990 for this exhibition. *SHARED VISIONS*, therefore, reflects the changing world of the American Indian artist as that world unfolded throughout the twentieth century.

At the close of the nineteenth century, Carl Sweezy, the Arapaho painter, witnessed the disappearance of the "buffalo road" as white settlers flooded into Indian domain. Born in 1881, Sweezy became one of the first professional Native American painters. He used watercolor and house paints on butcher paper and canvas as a way of preserving tribal memories and legends. Sweezy created a matchless record of the old ways, while creating for himself a new way as an artist. His paintings, although a catalogue of Arapaho history, dress, games, religious life, and customs, are much more than ethnographic curiosities. Their artistic vitality transcends the act of merely recording exotic subject matter.

Sweezy's work is poignant. It is the story of a way of life coming to an end, of a people drawing upon tradition to help themselves survive. Sweezy's canvases explore the world of Indians embarked on the "corn road," which was designed by whites to transform nomadic Indian hunters into settled dirt farmers. His paintings speak directly and simply. They evoke "a link between the old, free-roaming buffalo days and the modern Arapaho who lives much like his white neighbors."[2]

Sweezy paints, with urgency and vitality, the heart and soul of a civilization. He captures the affection and security that an Indian child felt as a part of an extended family and suggests how the Arapaho used these and other historic values to adjust to the restrictions of reservation life. He preserves with remarkably little sentimentality the strength and spirit of the old ways, while exploring new Indian ways, such as "the Peyote Road."

Neither we nor our dogs nor our ponies understood this way of white people, Sweezy remembers. To us it seemed unsociable and lonely, and not the way people were meant to live. [3]

5

In many ways, Carl Sweezy's work embodies the changing world of twentieth century Native America. His was a world of dislocated tribes and impacted villages, of a peoples' response as the power of government pressed down on their societies. The Indian was caught on the crest of one of those great cycles that recur throughout American history.

Westward expansion was itself an old story, but this nineteenth century expansion was somehow different. It was more determined, better organized, much faster, more efficient, and more difficult to resist.

Powered not only by technological marvels, such as the railroads, the steam engine, and the mechanical harvester, the new expansion was also propelled by the "go getter" spirit that infused the nation after the Civil War. The energy of the Union victory survived on the frontier. A determination to thrust the nation westward ruled in Congress and, more importantly, in the boardrooms, taverns, and churches. Landless Americans from earlier-settled areas of the country and immigrants to America demanded Indian land. There was little sympathy for the preservation of a way of life that left land unturned, coal unmined, and timber uncut.

The goals and values of white and Indian civilization were incompatible. The Indians' hunter culture with seasonal migration patterns that followed the herds was particularly marked for extinction.

To assure that white values lived and Indian civilization died, the federal government used the full power of the law and established "courts of Indian offenses" to wipe out old "heathenist" practices. The thrust of this federal law was to end Indian culture. To the Indian, this new life was discouraging, demeaning, and debilitating. Health problems were serious. Whole tribes were virtually decimated. Commonly held tribal lands were forcibly allotted in a way designed to move Indians into the white land base.

Education was a primary force in destroying the old Indian ways. Aged Indian men and women still remember the harshness of their childhood experiences at Indian boarding schools where they were forbidden to speak their Native tongues and were punished – often beaten – if they lapsed into their own language or customs.

Occupational reform was the "program" for adults, and the primary focus of that reform was agricultural. Native warriors were to become "Red Old MacDonalds." Many Indian males, in order to sustain their families and keep body and soul alive, were forced to become farmers, working with horse and plow.

It was into this world of enforced change that Carl Sweezy and the twentieth century Native American Fine Art Movement was born. Sweezy, who faced the limited options open to Native Americans of his generation, chose to become a painter, not just an occasional dabbler on canvas, but a man whose life work, whose controlling passion, was to be an artist.

This decision to become a professional artist was subsequently made by countless other Native Americans. Scott Momaday, the Pulitzer Prize-winning novelist, wrote of that fateful choice made by his own father, the Kiowa painter, Al Momaday. Scott Momaday recalled:

> By the time he was a young man my father had got enough of farming. He wanted to be an artist, a painter At some point he moved out of that old world of the Kiowas. Like Mammedaty [his grandfather], he would make a life for himself. I know now that this was an act, not of renunciation, but of profound affirmation, and that it required considerable courage and strength. My father was born in a tipi in a world from which it was both necessary and costly to succeed.[4]

Affirmation is a motivating force behind much of the work of Native American painters and sculptors – the affirmation of what Sweezy called "the way people were meant to live." Twentieth century Indian art is about survival – the survival of the spirit. In a way, this art was the counterbalance to the federal effort to destroy all that was Indian. The Indian artist knows the lesson of building and rebuilding a civilization, of adapting, of changing, and yet of remaining true to certain basic values regardless of the nature of change. At the heart of those values is an understanding and appreciation of the timeless – of family, of tribe, of friends, of place, and of season.

Another of the early Indian painters, the Shawnee artist Ernest Spybuck (1883-1949), was born on the Great Plains less than four years after Sweezy. Spybuck's works are significant examples of the Indian artist as recorder, conveyor, and preserver of traditional values in the midst of societal change. It is not possible to know the paintings of Spybuck without understanding that new houses, brightly painted wagons, peyote drums, and western saddles do not change the spirit of Indian people nor the vitality of their gatherings. His narrative genre paintings preserve the details of daily life, while looking deeply into the heart and soul.

Generally speaking, twentieth century Indian painting and sculpture explore the drama, excitement, and exhilaration of life. Many works address simple daily tasks, others depict the modern pan-Indian world of fairs and pow wows. A large number are rooted in the spiritual complex of ancient ways and in the evolving religious worlds of peyotism. Many deal with myths and legends. A hallmark of the early traditional painters is a meticulous attention to the accuracy of the Indian elements in their works. Thus, Indian paintings are true sources for insight into Indian culture.

Too often, students of American Indian art have considered Native painting as nothing more than an elaboration or extension of the design elements in pottery or baskets, or perhaps a refinement of ledger drawings or pictographic sketches. In truth, twentieth century American Indian painting and sculpture is much more.

Today's Indian artist portrays experiences close at hand and paints the artifacts of his contemporary world. The conventional themes of Indian painting: richly costumed ceremonials, frantic hunts, and brightly-attired fancy dancers, have begun to fade before new images of social commentary, personal inspiration, and abstract experimentation. Yet, with only a few exceptions, all continue to address the broader issue of the "way people were meant to live." These works transcend the tribal experience and look at global questions. The arts of the Native American speak directly of human concerns, of the privileges and obligations of the generations. They embody the laments of bereavement, the intoxication of first love, the new mother's fear and joy, and the father's pride. They proclaim the triumph of war, the transience of glory, and the resignation of age. As Native people, these artists work systematically at training themselves, often in studios, art schools, and salons. They consider their work to be not only to and about Indians, but also about the world at large.

The Native American Fine Art Movement was born in crisis – created by an officially ordained program of cultural genocide; the homelessness of urban relocation; the bankruptcy of tribal termination; and the hopes and the frustration of Indian veterans returning from foreign wars. Over the last five or six generations, Indian painting has been in the eye of the rapidly moving whirlwind that is the Indian's struggle for survival. Indeed, survival is the word that best describes the spirit of the work of Indian artists as diverse as Carl Sweezy, Tonita Peña, W. Richard West, Fritz Scholder, and Kay WalkingStick. Each generation, in its own way, represents a different phase not only of the Native American Fine Art Movement but also of the American Indian experience.

In many ways, the Native American Fine Art Movement is as diverse as the world of the artists themselves. Modern Indians are people of varied and contrasting cultures. There are more than five hundred separate tribes, bands, and villages of Native Peoples totaling more than 1,500,000 citizens. In addition, there are perhaps four to five times that many people of Indian heritage who are not officially enrolled tribal members. Contemporary Indians reside on reservations, in cities, and on farms. They are predominantly young, with more than half under the age of twenty. Indians constitute one of the fastest growing population groups in the United States and are found in every continental state, the District of Columbia, Alaska, and Hawaii.

Today, Native Americans, the so-called "First Americans," are the "Last Americans" in terms of income, employment, health care, educational opportunities, and other statistical measures of well-being. The Indian at the end of the twentieth century is in much the same position as the Indian at the close of the nineteenth century.

There is, however, at least one major difference. It is no longer possible to believe that the Native American is the "Vanishing American," that the "Redman" is on the road to disappearance. The modern Indian is very much alive and well. The determined effort to destroy Indian culture and break Indian pride failed. And art – The Native American Fine Art Movement – was one of the reasons for the failure of this cultural genocide. The great legacy of Carl Sweezy, Ernest Spybuck, and other dedicated Native Americans artists is that they have helped Native Americans understand and preserve that which is unique and valuable in the traditional Indian ways. Despite these diverse styles, they have helped create an understanding that Indian life and culture are evolving, and, that as the material aspects of a culture change, basic values need not be sacrificed.

In many ways, Native American art reflects the diversity of the artists' experiences. Carl Sweezy was commissioned by the anthropologist James Mooney; Ernest Spybuck painted on demand for the Museum of the American Indian; Julian Martinez adapted historic pueblo symbols to canvas; Oscar Howe worked in the manner of the Cubists; Waldo Mootzka was at home with deco designs; Stephen Mopope studied with Oscar Jacobson; Frank Day worked in quiet isolation; George Morrison was present in New York at the birth of Abstract Expressionism; Allan Houser was a student of Dorothy Dunn's in Santa Fe; R.C. Gorman studied in Mexico; Fritz Scholder acknowledges his debt to Francis Bacon; Patrick DesJarlait painted for commercial beer advertisements; Joe Herrera merged the traditionalism of his mother, Tonita Peña, and the Taos school; and Helen Hardin and Michael Kabotie learned from their distinguished artist parents as well as from the new works of Joe Herrera.

Moreover, the Native American Fine Art Movement has been influenced by many centuries of interaction between native and colonial societies. Indian painting and sculpture cannot be viewed in isolation. Instead, it must be considered in light of the impact of such varied institutions and individuals as frontier artists, pioneering ethnographers, traveling nobility, military parties, wars and treaty negotiations, Indian agents, missionary stations, boarding schools, white homesteaders, government policies, railroads, miners, scholars, critics, art patrons and collectors, tourists, world fairs, the movies, museums, art galleries, and the G.I. Bill of Rights. In short, Indian painting and sculpture have been shaped by all that has shaped the Indian who paints and sculpts.

In addition, there are influences that exerted a great impact upon Indian art, including specific art courses such as Oscar Jacobson's courses for the Kiowas at the University of Oklahoma, Dorothy Dunn's Studio at Santa Fe, the Rockefeller Conference, and the Institute of American Indian Art. Other landmarks include the shows at the Museum of Modern Art and the federal arts projects of the 1930s that particularly supported public murals, as well as the

efforts of the Indian Arts and Crafts Board. In recent years, the art departments of colleges and universities, art institutes, and the interaction of artists – Indian and non-Indian – have impacted significantly on Native American fine art.

Native American painters, including George Morrison, T.C. Cannon, Fritz Scholder, James Havard, and George Longfish, were increasingly influenced by modern non-Indian painters, who were in turn influenced by the primitive – a classic example of cross-fertilization. How often do we hear or read about this remarkable chapter in American art history? It is like a mirror reflecting back upon a mirror. The contemporary Indian mirrors the Cubist and the Abstract Expressionist, who mirrors the carver of Indian masks, who mirrors a Native world view.

Why is the work of these twentieth century Indian painters and sculptors virtually unknown? Why is the story of the Native American Fine Art Movement rarely studied? Why is Indian fine art almost never seen and, when exhibited, often viewed only as an adjunct to Indian arts and crafts shows or as ethnographic specimens in museums of natural history?

This neglect or indifference raises particularly intriguing questions for the art historian. Why, for example, is the historic abstract nature of Indian art ignored and the painting of specific twentieth century Indian artists omitted from art historians' discussions of Modern and Post-Modern art movements? Why have there been periods when interest in Indian fine arts seemed to flare and then quickly burn out?

The deafening silence about Native American fine art by art historians and the museum establishment is particularly ironic. Students of the history of Modernism in art are familiar with the depth of contemporary American and European artists' interest in Traditionalism or Primitivism. For example, the influence of African and American Indian masks can be seen in the work of contemporary painters and sculptors from Picasso to Moore to Pollock. Indian sandpainting, Pollock acknowledges, was crucial in the development of what some call his "spill canvasses." It is, indeed, ironic that the moderns forced us to understand the sophistication of the primitive and to appreciate differing levels of reality without understanding the relationship of those questions to the Native American Fine Art Movement.

J. J. Brody in his classic study, *Indian Painters & White Patrons*, identified the colonial nature of a patronage system that narrowly defined and dictated what was "Indian art."[5] Beyond that, the overriding societal stereotypes of the Native American seem to have ordained a kind of obscurity for the Native American Fine Art Movement. Is there a socially rooted unwillingness to acknowledge Indian painters as anything more than naturally talented, primitive children drawing upon an aboriginal artistic chromosome to spiritually emote? Is there a sense that Indian painting is irrelevant in the context of modern life, that Native Americans are themselves a historic throwback and, therefore, what they create is, of necessity, only of historic or anthropological value? It seems almost as if definitionally the Indian cannot be accepted as a serious, professional artist and that paintings by Indians can be considered only in a primitive, aboriginal context. There appears to be a bias which sees Indian art exclusively as "ethnic art" that does not flow from or into the mainstream, regardless of the training, experience, competence, professionalism, or inspiration of the Native American artist.

An eloquent statement of the maturing Indian fine artist, who is thwarted in developing new directions in painting and striving to break away from the old stereotypes limiting Indian art, is found in a letter from the Sioux painter, Oscar Howe. The letter was written to Jeanne Snodgrass (King) after one of Howe's Cubist style paintings was rejected from the 1959 Indian Artists Annual because it was "non-Indian" and embodied a "non-traditional Indian style."

...There is much more to Indian Art, than pretty, stylized pictures. There was also power and strength and individualism (emotional and intellectual insight) in the old Indian paintings. Every bit in my paintings is a true studied fact of Indian paintings. Are we to be held back forever with one phase of Indian painting, with no right for individualism, dictated to as the Indian always has been, put on reservations and treated like a child, and only the White Man knows what is best for him? Now, even in Art, 'You little child do what we think is best for you, nothing different.' Well, I am not going to stand for it. Indian Art can compete with any Art in the world, but not as a suppressed Art.

I see so much of the mismanagement and treatment of my people. It makes me cry inside to look at these poor people. My father died there about three years ago in a little shack, my two brothers still living there in shacks, never enough to eat, never enough clothing, treated as second class citizens. This is one of the reasons I have tried to keep the fine ways and culture of my forefathers alive. But one could easily turn to become a social protest painter. I only hope the Art World will not be one more contributor to holding us in chains.[6]

The Indian artist as serious professional painter or sculptor is hidden beneath racial and ethnic stereotypes. This is at the heart of the distorted popular history of the Native American Fine Art Movement. It is also central to the failure of so many major museums to exhibit the works of Native American painters and sculptors.

The experience of the talented young Creek artist Jerome Tiger (1941-1967) illustrates the manipulation of image to reinforce white preconceptions. Tiger's patron and dealer, Nettie Wheeler, was relentlessly committed to the promotion and recognition of her "Indian artistic discovery." In response to a letter about the exquisite detail of one of his early watercolors and his remarkable execution of the human anatomy, Wheeler replied, "Jerome Tiger had no training in the white man's art world. He taught himself by study of his own body."[7] In reality, Tiger had devoted himself to the hard task of mastery of human anatomy while he studied at the Cleveland Art Institute. Tiger was a brilliant artist who struggled to learn all there was to know about art, and he didn't worry about the source of that knowledge. His sketch books from formal art courses survived his tragic, untimely death at the age of twenty-six and show his academic training in life drawing. Because Nettie Wheeler demanded that Indian art must be "natural," Tiger's own artistic achievement as a painter is denigrated.

"We [Indians] do have something to give the art world," declared Geronima Montoya, the San Juan Pueblo artist who studied at the Santa Fe Indian School with Dorothy Dunn and later at the Institute for American Indian Art. "The more you think about it," Montoya continues, "the more you know that is true: we do have something we can share with the world."[8]

The experience of America's Native People seen from the artists' perspective offers a powerful message about cultural persistence and change. As the world moves toward the twenty-first century, the artistic and cultural vision of twentieth century Native American artists can help all mankind appreciate the dual task of preserving historic values while building new traditions. These artists can help in understanding the universal challenge of responding to cultural and technological change.

The strength of the Indian in the changing world is sharply focused in the paintings of the late Kiowa-Caddo artist T.C. Cannon. The most vivid of these is Cannon's famous "Collector #5," known also as "Osage with Van Gogh." As a painting, a poster, and a woodcut, "Collector #5," has taken on an independent artistic significance. Abstract issues are personified by this finely-dressed Osage sitting in his wicker chair beween a Navajo rug and Van Gogh's "Wheatfield." The worlds of mainstream and Indian art are represented here.

In a sense, this is a modern version of Wohow's ledger drawing from Fort Marion in which a Kiowa warrior stands symbolically poised between a buffalo and a cow, between the hunt and the farm. Cannon is saying that the modern Indian makes his own culture and his own art, drawing from all worlds. The confident and smiling Osage proclaims that whatever he makes or does, traditional or modern, is uniquely, appropriately Indian.

Painting and sculpture of American Indian artists provide a unique opportunity to look into the world of the Native American. Paintings are a rich storehouse of images of the Indian created by the Indian. This is the world as seen by the Native American painters.

Pluralistic mainstream society can thus learn what the Indian has to offer. It can begin by appreciating the art, philosophy, religion, literature, music, and dance of the Native American. Are the tales of the Brothers Grimm, Hans Christian Anderson, and the politically-minded Mother Goose more fitting fare for American children than the friendship of thunder, the brotherhood of the bear, and the origin of corn? The story of the Indian is the story of America.

The novelist, D.H. Lawrence, in his *Studies in Classic American Literature* observed,

> {T}he spirit can change. The white man's spirit can never become as the red man's spirit ... But it can cease to be the opposite and the negative ... It can open out a new great ... consciousness, in which there is room for the red spirit, too.[9]

[1] Bass, *The Arapaho Way: A Memoir of an Indian Boy*, 33-48.

[2] Ibid., 33-48.

[3] Ibid., 33-48.

[4] Momaday, *Names: A Memoir*, 36-38.

[5] Brody, *Indian Painters & White Patrons*.

[6] Dockstader, ed., *Oscar Howe: A Retrospective Exhibition*, 19. Letter of Oscar Howe to Jeanne Snodgrass (King), April 18, 1958, cited in King essay.

[7] Parson, *The Art Fever: Passages Through the Western Art Trade*, 38-40.

[8] Seymour, *When the Rainbow Touches Down*, 2.

[9] Lawrence, *Studies in Classic American Literature*, 67-92.

AUTHENTICITY AND SUBJECTIVITY IN POST-WAR PAINTING: CONCERNING HERRERA, SCHOLDER, AND CANNON

W. Jackson Rushing

The recent literature on modern and contemporary art, especially that concerning the various manifestations of avant-garde primitivism, has often focused on the decontextualization or appropriation of African, Oceanic, and Native American art. But relatively little has been written about non-Western appropriations of Euro-American traditions, modernism in particular. The Indian response to techniques and materials of European origin began, of course, early in the contact period and is well-documented. The art of Woodlands and Plains Indians, for example, was transformed by the introduction of glass beads which generally replaced the older tradition of quillwork decoration. The presence of floral designs in such beadwork may be traced, ultimately, to French sources. American flag designs – beaded or painted – are not uncommon in nineteenth century Plains art; and the proto-modern period of Indian painting began when artists on the Plains and in the Southwest acquired, in varying circumstances, non-traditional materials: ledgerbooks, drawing paper, crayons, pencils, and watercolors.[1]

The controversy over appropriation, stylistic hybrids, and authenticity in *contemporary* Indian art is a conflict that has been played out before in this century. However, like other rapid-fire developments in the American art world, each of these controversies has a shorter life than the one before. For example, Fritz Scholder's Pop/Expressionist *Super Indians* series, which was begun in 1967 and is indebted stylistically to Francis Bacon, Wayne Thiebaud, and perhaps Nathan Oliveira, has long since become an aspect of art history.[2] But even before the Indian art revolution of the sixties, initiated at least in part by Scholder's commercial success and his presence on the faculty of the Institute of American Indian Arts (IAIA) in 1964-1969, "Traditional" Indian painting in the Southwest was irrevocably transformed by Joe H. Herrera's *Pueblo modernism*. Herrera's encounter with, and response to, modernism needs to be reconsidered in the context of appropriative strategies, not only because his work greatly influenced the development of Southwestern Indian painting, but also because new information makes it possible to see with greater clarity than before the complex relationship between Herrera and Raymond Jonson, his modernist mentor, and between ancient and modern pictorial traditions.

Joe H. Herrera (Cochiti)
"*Cochiti Green Corn Dance,*"
c.1947 (fig.1)

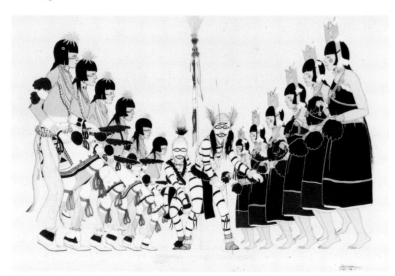

Herrera was born in New Mexico at Cochiti Pueblo, son of the celebrated painter, Tonita Peña from San Ildefonso. His uncles included the painters, Romando Vigil and Julian Martinez, and he recalls being inspired in his youth by the works of Awa Tsireh, as well as being taught by his mother.[3] Following his graduation from The Studio of the Santa Fe Indian School in 1940, where he studied with both Dorothy Dunn and Geronima Cruz Montoya (San Juan), Herrera achieved considerable recognition for watercolors depicting Pueblo dances and genre scenes done in the flat, decorative, "Traditional" style, which had been created by his mother's generation and was

institutionalized at The Studio after 1932. As J. J. Brody has demonstrated, The Studio style was only tenuously connected to aboriginal painting traditions and was shaped to a remarkable degree by the expectations of non-Indian patrons, who functioned as "form-creators."[4] It was, nevertheless, the dominant, well-established style of Indian painting in the Southwest and one that Herrera had seen practiced all his life. Furthermore, given the awards and institutional recognition he had received for paintings in this style, such as *Cochiti Green Corn Dance* (c. 1947; fig. 1), it is all the more astonishing that he had the courage and the vision to challenge the strictures of this "tradition" by appropriating a modern, an *apparently* non-Indian style.

Joe H. Hererra (Cochiti)
"Petroglyph Figures,"
c.1952-1956 (fig.2)

After serving in World War II, Herrera studied with first-generation American modernist Raymond Jonson at the University of New Mexico from 1950 to 1953.[5] Herrera readily admits that the time spent as Jonson's student was crucial to his development: "We were taught at the Santa Fe Indian School what traditional Indian art was supposed to be, but Jonson exposed me to world art."[6] Not surprisingly, *world art* turned out to be Cubism, the art and theory of Wassily Kandinsky, and the primitivist works of Paul Klee, which Herrera logically saw as similar to Anasazi pictographs. But more important, perhaps, Jonson encouraged Herrera to study Anasazi rock art, as well as pueblo symbols and geometric designs. Simultaneously, Herrera was studying photography and anthropology, which led him to photograph ancient rock art sites. The confluence of these various stimuli resulted in paintings, such as *Petroglyph Figures* (c. 1952-1956; fig. 2), in which Herrera used a spatter technique, which, although similar to the spray technique used by Jonson, was derived from the spatter technique used in prehistoric kiva murals, such as those excavated at Rio Puerco and Awatovi.[7]

Herrera's *Pueblo modernism* was in full bloom by 1952, when he had his first one-person exhibition at the Museum of New Mexico. That same year, his new work received awards in a number of competitions, was financially successful, and was, in some quarters at least, critically acclaimed.[8] In 1954, he took all the top honors at the Gallup Intertribal Ceremonial, including *Les Palmes Academiques* awarded by the French government.[9] *Pictograph Altar* (1952; fig. 3), with its telluric surfaces, is typical of the most successful paintings in this new style. The large, dark, biomorphic shape that dominates the painting is inscribed with an anthropomorphic, pictographic altar consisting of a mask-like head/face and rectangular body. This geometric body is divided by means of a linear grid into compartments containing polychrome, hard-edged forms that signify Pueblo art, culture, and history: kiva-step motif, cloud/mountain forms, bear paw,

handprint, serpents, and abstract designs. Emerging from the left side of the body is the head of a bird whose tail feathers are visible at the top right. These images, associated with nature and landscape, and thus, Pueblo ritual life, are not necessarily secret ones, but are found in other art forms, such as mural painting, pottery, and textile design, and, of course, rock art. As Herrera himself has stated, "when you do paintings of more esoteric nature than public dances, there can be tribal pressure." He added, "I have to be careful... because I participate in a sacred society, I must respect certain limits about subject matter in art."[10]

Joe H. Herrera (Cochiti)
"Pictograph Altar,"
1952 (fig.3) Photo credit: Denver Art Museum

As Herrera observed in a recent interview, his modernist paintings constituted a direct challenge to the absolute authority of The Studio style. In fact, he insists that it was always a misnomer to speak of The Studio style as "traditional." As a result of his encounter with Jonson's modernism, he felt liberated from the subject matter of The Studio, which allowed him "to pursue his own vision."[11] In some instances that meant "pure" abstraction, such as *Design*, an apparently non-objective painting from 1950 now in the collection of The Jonson Gallery at the University of New Mexico (fig. 4). Despite the fact that these "post-Jonson" paintings, with their debt to synthetic Cubism and biomorphic abstraction, were championed by some, they were rejected by others as not being real Indian art. Purist collectors, certain tribal elders, and even Herrera's own mother, criticized his move away from "traditional" Indian painting.

If it is problematic for the contemporary audience to see why these modernist paintings were so controversial in the early 1950s, it is partly due to the fact that they have been extremely influential in the ensuing years. A number of artists have responded to Herrera's style and imagery, including the late Helen Hardin (Santa Clara) and the late Charles Lovato (Santo Domingo), as well as some of the Artist Hopid. Following Herrera's lead, these painters too, incorporated the forms and iconography of prehistoric and historic Pueblo art that had been neglected, generally, by The Studio. As such, in a "Kublerian" sense, Herrera may be seen as having reopened what had appeared to be a closed sequence.[12] He did this by appropriating Pueblo pictorial forms and using them in a modern format – the easel painting. The appropriated images – pictographs and geometric designs – were revitalized by means of Jonson's modernist style of representation, which was itself based, in large measure, on the appropriation of Native American art of the Southwest.

What has never been explained in any of the previous attempts to explicate the meaning or historic importance of Herrera's modernist work, is that Jonson's abstractions, after he settled in Santa Fe in 1924, were indebted to pictographs and to the geometry of Pueblo architecture, pottery, and textile designs.[13] In the early 1930s, for example, Jonson produced a series of works collectively known as the "Indian Design Motifs," typified by *Southwest Arrangement* (1933). The forms and shapes of these geometric abstractions were derived from examples of Pueblo art in the collection assembled by Jonson's wife, Vera. Indeed, Herrera has confirmed that Jonson kept baskets, pottery, and textiles in his studio and that he used them in developing designs.[14] Jonson himself recorded that this collection was a precious and personal part of his daily environment.[15] In 1946-1947, Jonson once again made Southwest Indian art the focus of a series of seventeen paintings, which he titled *The Pictographical Compositions*. Like Herrera's later modernist paintings, these works, such as *Pictographical Composition No. 7* (1946), have textured surfaces and respond in an intuitive manner to the abstract linear rhythms of prehistoric rock art. Little wonder then, that Jonson would encourage Herrera to abandon the genre subjects of The Studio in favor of truly traditional forms of art, or that the latter would be so receptive to his teacher's modern (read primitivist) style.

Joe H. Herrera (Cochiti)
"Design,"
1950 (fig.4)
Photo credit: Jonson Gallery, University of New Mexico, Albuquerque

Despite the audience's continued interest in Herrera's new-old style of painting,[16] the work has been described as a failure for its use of "specific symbols or iconographic elements," as opposed to the "generalized 'universal' symbols" used by such modernists as Kandinsky, Klee, and the Surrealists, who conceived the symbols as having "universal evocative associations."[17] This conclusion is problematic for two reasons. First of all, the revisionist critique of modernism has contested the belief that Kandinsky's "basic geometric forms" or Klee's "use of the fish as a symbol of Christ" could communicate "universal subconscious meanings."[18] Secondly, there is the fact that Herrera, a convert to modernist ideology, insists that he believed in the "universality of 'primitive' symbols." Like Adolph Gottlieb, whose "Pictograph Series" (1941-1951) also incorporated ancient southwestern rock art, Herrera believed in art as a "language speaking across cultures."[19] Even if such a belief is now contested, Herrera was quite simply practicing a faith, one shared by many in the art world in the 1940s and 1950s, which held that "primitive" forms were essential and transcendent. Thus, only an ahistorical interpretation makes it possible to call his revived pictographs a failure on the grounds "that words are necessary to explain the meaning of a picture that is intended for a specific audience."[20] Beside the fact that it is widely conceded today that "words" (i.e., language) and other factors always qualify the audience's response to the visual arts, there is the historical context: in the early 1950s, both Herrera and the intended audience, non-Indians, believed in an aesthetic-spiritual meaning beyond language. The proof of this is in the popularity of Herrera's work and of those artists who developed styles that extended the sequence he reopened by modernizing aboriginal pictorial forms. His most important achievement, however, was a successful interruption of the dominance of The Studio style, and the Euro-American definition of "authentic" Indian painting that it sustained. Thus, his search for a *mode of representation* appropriate to his subject matter was simultaneously an expression of an authentic subjectivity as he perceived it.

In the last decade, history and criticism of the visual arts, especially of those cultures with a colonial heritage, have focused increasingly on theories of representation. Concerned with the role of representation in constructing, enforcing, or resisting power relations, scholarship has gone beyond the investigation of "an artistic likeness or image" towards an understanding of images-as-texts that "influence opinion or action." With the visual arts now conceived as a form of discourse shaped by cultural and historical factors, there has been a "movement from analysis of artistic products toward consideration of the production of meaning."[21] Ethnicity, as in "what does it mean to be an authentic Indian?" is the product of discourses, such as the visual arts, that are both intrinsic and extrinsic to any particular culture. But these same discourses also produce other kinds of subjectivity besides ethnic, so that Kate Linker's comments on representation and sexuality are also instructive in this context.

> *Representation, hardly neutral, acts to regulate and define the subject it addresses, positioning them by class or by sex [or by "race"], in active or passive relations to meaning. Over time these fixed positions acquire the status of identities and, in their broadest reach, of categories. Hence the forms of discourse are at once forms of definition, means of limitation, modes of power.*[22]

Native America's *postmodern* interrogation of an Indian subjectivity, passive in relation to meaning and established by representation(s), began with the paintings of Scholder (Lusieño) and T.C. Cannon (Caddo/Kiowa). Before examining specific works of art that demonstrate this interrogation, it is necessary to explain, briefly, how it is that Scholder and Cannon can be discussed as postmodernists. Douglas Crimp has written that "if *postmodernism* is to have

theoretical value, it cannot be used merely as another chronological term; rather it must disclose the particular nature of a breach with modernism."[23] Similarly, Hal Foster has described a resistant *postmodernism* "which seeks to deconstruct modernism and resist the status quo."[24] Influenced by Andreas Huyssen's insistence that modernism was dependent on the distinction between high art and popular culture, Joseph Traugott has argued for seeing Scholder and Cannon as postmodernists for having made a breach with modernism that resisted the status quo as it pertained to the relationship between subject matter and style.

According to Traugott,

> *these artists...worked with social issues and cultural stereotypes during the 1960s and 1970s. They reveled in their presentations of mass culture visions within a modernist format. While the expressionist strokes in their works may seem modern, the content of their art was clearly mass-culture social commentary. The mass-culture content combined with high-culture styles appears to be anti-modern, or a kind of incipient post-modernism, according to Huyssen's analysis.*[25]

Unlike Herrera, who used a "modernist" style derived from ancient Indian art to signify elements of traditional Native American culture in the Southwest, Scholder and Cannon used styles associated with the "dominant" culture – Post-Impressionism, Expressionism, and Pop Art – to probe the personal and social dilemmas of authentic, but non-traditional Indian culture(s).

When Linker's ideas about representation are applied to the question of Indian subjectivity, the motivation behind Scholder's *Super Indians* is greatly clarified. By the time Scholder arrived at the University of Arizona in 1960 to participate in the Southwest Indian Art Project sponsored by the Rockefeller Foundation, more than a century of romantic images of Native Americans had created a fixed, if fictive position for them: noble, exotic, "Other." By repetition (in painting, literature, film, popular culture, etc.), the meaning of this passive position – passive because it resulted not from Indian speaking, but from being spoken about–had served to define Indian identity. And although production and maintenance of the primitivist trope, the Noble Savage, was the result of shifting historical circumstances, ideology had done its work, making the meaning of Indian identity "immutable and timeless."[26] Thus, as a critique of representation, Scholder's *Indian with Beer Can* (1969) and *Indian Wrapped in Flag* (1976, fig. 5) had everything to do with the deconstruction of a historically constructed, but now-fixed, fictional identity. For example, Scholder has explained that "in reacting against the romantic cliches of the Old Taos School of painters," all he "was trying to do was approach a loaded subject – the American Indian – in real terms."[27] When he first began teaching at the IAIA in 1965, Scholder noticed that "there was this tradition of Santa Fe painters who had come from the cities and were very blown up about painting the 'noble savage' and all that."[28] He determined initially not to use the Indian as subject matter, but frustration over his IAIA students' inability to "master...their Indian subject" persuaded him "that somebody should paint the Indian subject matter that the students were trying and do something with it that wasn't a huge cliche."[29]

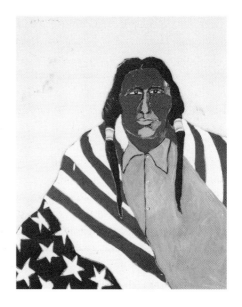

A substantial part of the problem, no doubt, encountered by Scholder's students as they tried to master the Indian subject, was that the subjectivity foisted upon them by representations was completely at odds with their own experience. Alienated and angry, they simply could not relate, in the early sixties, to the meaning of Indianness produced by Euro-American representations. Nor were they able to identify, many of them, with Indian versions of this same subjectivity as seen in The Studio style, which after all, was primarily "a commercial folk art" produced "for use as a decorative object or document."[30] Evidence for this conclusion is the collective self-portrait they made while studying at the IAIA. In 1982, I examined hundreds of slides at the IAIA representing student work from the school's first twenty years. One of the most prominent features of this record was the dozens of self-portraits which have blurred, indistinct, and/or fragmented facial features. Lloyd New, founding Director of the IAIA, explained that these were self-portraits of young artists who knew that neither were they enfranchised as members of American society, nor were they living the historic reality of their ancestors[31] (as they perceived it through representation). Realizing their marginality, relative to "mainstream" culture, and experiencing simultaneously a sense that they were not leading *authentic* Indian lives, they portrayed themselves in a liminal identity. The success, therefore, of Scholder's "monster Indians," as he described them, resulted from their arrival on the audience's "horizon of expectation." That is, in their "moment of historical appearance," his drunken, laughing, grimacing, expressionist/pop Indian subjects demonstrated an acute awareness of the audience's previous experience.[32] For surely the primary audience, initially, was his IAIA students, who responded positively to his ironic portrayal of the poverty, dislocation, and acculturation that were inescapable components of many Indian communities.[33] The fact that the traditionalists, Indian and Euro-Americans alike, found the *Super Indians* so controversial (even to the point of picketing his exhibitions) only demonstrates that Scholder had performed a highly effective interrogation of earlier representations of Indian subjectivity. Both the complexity and legitimacy of this critique were extended almost immediately by T.C. Cannon's representations of the Indian subject.

T.C. Cannon's death at age thirty-two in an automobile accident in 1978 was a tragic loss to the American art world in general, and to the Indian art community in particular. He was perhaps the most accomplished of the first generation of IAIA students. In his short life, he had numerous solo exhibitions and a two-person show with Scholder at the Smithsonian Institution in 1972, and was an artist-in-residence at Colorado State University (1974) and at Dartmouth College (1975).[34] Even a cursory glance at his works reveals an art born of extremely diverse stylistic sources. Although he shared with Scholder a taste for the fluidity of Wayne Thiebaud's lusciously colored forms, only occasionally is Scholder's influence directly apparent, as in *Beef Issue at Fort Sill* (1973). In a number of works, including *Cross the Powder and It Is War* (1970), the use of stenciled texts reveals an awareness of the proto-pop and pop sensibilities of Jasper Johns and Robert Indiana, respectively. The intensely graphic nature of his paintings makes overtures to Andy Warhol, just as the color-structure evokes, at times, Richard Diebenkorn.[35] But all this is to say that Cannon was keenly conscious of contemporary art, which indeed he was, but says nothing about the way his paintings were built on the appropriation of the patterns and flat decorative forms of Paul Gauguin's synthetism, and of Art Nouveau in general. When pushed to the extremes, as in *Beef Issue at Fort Sill* or *Chief Watching* (1978), the profusion of decorative patterns creates an Op art effect that threatens to overtake the representational subject matter. This potential loss of the narrative subject due to decorative dematerialization suggests, once again, late nineteenth and early twentieth century French painting.

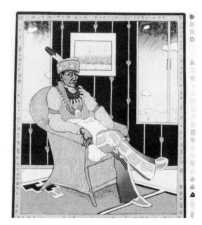

T.C. Cannon (Kiowa/Caddo)
"*Collector #5,*"
1975 (fig.6)

The fact that two of Cannon's most provocative paintings, *Collector #5* (1975, fig. 6) and *Self-Portrait in Studio* (1975, fig. 7) present figures in psychologically charged interior spaces also supports the idea that French painters –*Les Intimists* (Bonnard and Vuillard) and Henri Matisse – may have provided him with a point of departure. In *Collector #5* for example, Cannon looks through Matisse back to Gauguin and his contemporaries to create a rigidly abstract, architectonic pictorial structure: the floor and the wall in the back are contiguous; the vertical and horizontal interplay of firmly defined geometric forms establishes a taut, flat, planar space; and the severity of this linear order is relieved by the organic curves of the central configuration (Indian collector and his chair). Because of the temporal context of their production, the link between the colors of these paintings and Pop Art was immediately obvious; it is only in retrospect that one sees how much they depend on the passion of Matisse's Fauvist palette. This excursion into stylistic analysis demonstrates the resources available to Cannon – the layering of art history, as it were – in his effort to create an "avant-garde" context in which to deconstruct the primitive which is always inscribed in Primitivism.[36]

In *Collector #5,* Cannon shows the collector, an Indian in traditional clothing (beadwork, bear-claw necklace, moccasins, feathered fur cap, "peace" medallion, etc.) sitting on a wicker chair decorated at the bottom with a "primitive" design; on the floor is a Navajo rug and on the wall behind is a reproduction of Van Gogh's *Wheatfield.* Frowning, the collector stares with narrowed eyes at the audience. The angle of his body and the placement of the collected art of the wall, just above and to the right of his head, recalls Edgar Degas' portrait of English painter *James Tissot* (1866-1868). Similarly, the Indian collector's gruff visage was prefigured by the stern stare of Degas' *The Collector of Prints* (1866). Even if one is startled to see an Indian in an interior that combines Navajo textiles with nineteenth century art, the full impact of Cannon's parodic intention is dependent on knowledge of two very different kinds of preexisting representations. The first kind include images like the two Degas paintings cited here, which show elegant, cosmopolitan figures surrounded by high art. The second consists of late nineteenth and early twentieth century photographs of Native Americans in their finest regalia, posing in the Victorian "parlors" of the photographer's studio.

Likewise, the critique of representation inherent in *Self-Portrait in Studio* either succeeds or fails, depending on the audience's horizon of expectation. Cannon, dressed like a cowboy (the hero/villain of "cowboys and Indians") as many contemporary Indians do, is seated in front of a Navajo rug. The window behind him provides a view of a landscape that could double as Santa Fe colony modernist *painting* of New Mexican landscapes. To his left are a Dogon mask and a partial view of Fauvist/Expressionist painting. The narrative suggests at once numerous photographs of modern primitivists, such as Pablo Picasso, in their studios surrounded by tribal objects.[37] Only now, the "primitivist gaze" is reversed, and the Indian artist, who has appropriated numerous signs of modernism, including the collecting of modern and tribal art, fixes the audience with his cool, penetrating stare. If my discussion of Cannon's style was topographical, *in that I sought to map the surface in order to determine its structure,* then, as Crimp has explained, I was engaging in "description as a stratigraphic activity."[38] My reading of Cannon's parodic intention was similarly an effort to reveal the "strata of representation" constructed by his "processes of quotation, excerptation, framing, and staging that constitute"[39] an interrogation of the ideology of modernist primitivism. It is not my intention to devalue Cannon's originality as an artist by showing that *Collector #5* and *Self-Portrait in Studio* are inscribed with a consciousness of art history; the point is not to prove that ultimate source of the paintings exists elsewhere, but to establish, in Crimp's words, "structures of

significance." Cannon's work, producing layer of meaning as it does, is indicative of Crimp's assertion that "underneath each picture is always another picture."[40]

What Herrera, Scholder, and Cannon share(d), beyond a courageous willingness to disregard the immediate commercial advantages of working in the popular style of The Studio, was an understanding that pictures, with their layers of referents, have consequences. Their radical solutions to the problem of representing Native American subjectivity constituted an implicit rejection of a historically constructed artifice: an ahistorical Indian reality that embodied Euro-America's colorful Other. Because this process of othering (through representation) has contributed to the general oppression of Native American communities, the decision made by Herrera, Scholder, and Cannon to develop new styles of *authentic* Indian art was, consciously or otherwise, a political one. If, as Yve-Alain Bois suggests, "form is always ideological,"[41] then a stylistic rupture, especially one that challenges so directly the stereotypes produced by the politically dominant culture, is not merely an aspect of art history. Such risk-taking, with its potential for either productive intervention or critical marginalization, must be seen as central to the history of Native American resistance to Euro-American hegemony.

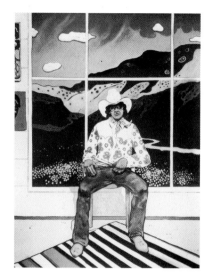

T.C. Cannon (Kiowa/Caddo)
"Self-Portrait in Studio,"
1975 (fig.7) Photo credit:
Jason Aberbach

[1] On these pre-modern adaptations to Euro-American influence, see Warner, "The Individual in Native American Art," in Edwin L. Wade, ed., *The Arts of the Native American Indian: Native Traditions in Evolution*, 179, 187.

[2] It has been suggested that the tortured, anti-heroic faces of the "Super Indians" were derived from the work of Billy Soza War Soldier (Cahuilla/Apache), who was one of Scholder's students at the IAIA; personal communication from Chuck Dailey, former curator of the museum at the IAIA (August 1982).

[3] Personal communication from Joe Herrera, Cochiti, New Mexico (January 10, 1987). See also his comments in Gray, *Tonita Peña*, 59-61.

[4] Brody, *Indian Painters & White Patrons,* 85, 114-117. On patrons as "form-creators," see Brody, "The Creative Consumer: Survival, Revival and Invention in Southwest Indian Arts" in *Ethnic and Tourist Arts,* 70. For a former student's perspective on the artificial restrictions of the curriculum at The Studio, see Allan Houser's comments in Highwater, *Song From the Earth*, 149-150.

[5] For Jonson's influence on Herrera see Brody, *Indian Painters & White Patrons*, 152-156, and Tanner, *Southwest Indian Painting,* 138-140. The latter, however, underestimated the significance of this relationship.

[6] Personal communication, 1987.

[7] Herrera, personal communication, 1987. Herrera reported that he worked at the Rio Puerco site near Las Lunas, New Mexico, in 1954, at which time he made copies of the excavated murals. Replicas of the Awatovi murals, created under the supervision of Hopi painter Fred Kabotie, had been exhibited at the Museum of Modern Art in 1941; see Douglas and d'Harnoncourt, *Indian Art of the United States,* 22-23.

[8] Brody, *Indian Painters & White Patrons*, 152. However, contrary to what has been reported by virtually everyone who has written about this period of Herrera's career, to this date I have seen no evidence to support the claim that he exhibited this new style of Indian painting at the Museum of Modern Art.

[9] See the clipping from the *Albuquerque Journal*, August 26, 1954, on file at the Jonson Gallery, University of New Mexico.

[10] Herrera, personal communication, 1987.

[11] Herrera, personal communication, September 16, 1990.

[12] According to George Kubler, "When problems cease to command active attention as deserving of new [aesthetic] solutions, the sequence of solutions is stable during the period of inaction." And yet, "any past problem [and its stylistic solution] is capable of reactivation under new conditions." Therefore, the pictorial forms and iconography of ancient pueblo art are "an open sequence in the twentieth century, because its possibilities are still being expanded by living artists" such as Herrera and others influenced by his work. See idem, *The Shape of Time*, 35.

[13] For a detailed discussion of Jonson's Indian-inspired primitivism, see Rushing, *Native American Art and Culture and the New York Avant-Garde, 1910-1950*, 278-293.

[14] Herrera, personal communication, 1987.

[15] Raymond Jonson, letter to Frank Hibben and J.J. Brody, August 20; on file in the archives of The Jonson Gallery, University of New Mexico.

[16] After a period of artistic inactivity beginning in 1957, during which time Herrera was active in state and tribal politics, he resumed painting in 1967. He continues to exhibit and to produce numerous paintings on commission, as well as create textile designs. Recently he completed thirty-eight illustrations for a book of pueblo stories. Personal communication, 1990.

[17] Brody, *Indian Painters & White Patrons*, 155.

[18] Ibid.

[19] Herrera's comments on art as a universal language that includes "primitive symbols" were a personal communication, 1990. On the Native American sources of Gottlieb's primitivism and his belief in the universality of ancient symbols, see Rushing, "Ritual and Myth: Native American Culture and Abstract Expressionism," in *The Spiritual in Art: Abstract Painting, 1890-1985*, 278-281.

[20] Brody, *Indian Painters & White Patrons*, 156.

[21] See Linker, "Representation and Sexuality," in Brian Wallis, ed., *Art After Modernism: Rethinking Representation*, 391-392.

[22] Ibid., 392.

[23] Crimp, "Pictures," in *Art After Modernism*, 186.

[24] Foster, "Postmodernism: A Preface," in idem., ed., *The Anti-Aesthetic: Essays on Postmodern Culture*, 12

[25] Traugott, "Native American Artists and the Post-Modern Cultural Divide," Annual Meeting of the College Art Association, 3. Traugott is referring to Andreas Huyssen, *After the Great Divide, Modernism, Mass Culture, Postmodernism*.

[26] According to Linker, "it is ideology's work that fixes...meanings as timeless and immutable, above the field of material conditions, rather than as shifting, in process;" See "Representation and Sexuality," *Art After Modernism: Rethinking Representation*, 392.

[27] Fritz Scholder, from an interview published in *The Indian Trader*, quoted in Highwater, *The Sweet Grass Lives On*, 117.

[28] Scholder, quoted in Highwater, *Song from the Earth*, 183.

[29] Ibid.

[30] Brody, *Indian Painters & White Patrons*, 189.

[31] Lloyd New, personal communication, Santa Fe, August 17, 1982.

[32] Cf. my comments on the exhibition, *Indian Art of the United States*, organized by Rene d'Harnoncourt for the Museum of Modern Art in 1941; Rushing, *Native American Art and the Culture and the New York Avant-Garde, 1910-1950*, 414. The idea of a "horizon of expectations" derives from Hans-Robert Jauss' description of an "aesthetics of reception and impact;" see idem, "Literary History as a Challenge to Literary Theory," *New Literary History*, 9. My comments follow Suleiman's discussion of Jauss; see Susan R. Suleiman and Crossman, eds., *The Reader in the Text*, 35-36.

[33] Cf. George Longfish and Joan Randall: "Scholder, who had refused to paint the Indian, found a way to do so in the sixties' context of the Institute. This was an era when all over the country, the young were demanding truer reflections of American reality." Idem, "New Ways of Old Vision," *Artspace*, 25.

[34] See Benton, "T.C. Cannon, The Masked Dandy," *American Indian Art Magazine*, 36-37.

[35] Besides Diebenkorn, Benton noted that Cannon was also interested in Balthus, Hundertwasser, R.B. Kitaj, David Park, and Egon Schiele; see Benton, "Cannon, Masked Dandy," *American Indian Art Magazine*, 35. According to the catalogue of a recent retrospective exhibition of Cannon's works, he was also interested in a number of early modern artists including Paul Cezanne, Vincent Van Gogh, and Henri Toulouse-Lautrec; see Wallo and Pickard, *T.C. Cannon, Native American: A New View of the West*, 32-33.

[36] See Torgovick, *Gone Primitive*, 22.

[37] See, for example, Rubin, ed., *Primitivism in 20th Century Art*, Vol. 1: 282, 299-300, 306, 330. Note also that one of Cannon's sketches portrays Picasso in an Indian warbonnet; see Wallo and Pickard, *T.C. Cannon, Native American: A New View of the West*, 32, fig. 33.

[38] Crimp, "Pictures," *Art After Modernism*, 186.

[39] Ibid.

[40] Ibid.

[41] Bois, "Resisting Blackmail: The Task of Art History Now," *The Journal of Art*, 65.

THE INSTITUTE OF AMERICAN INDIAN ARTS:
A CONVERGENCE OF IDEOLOGIES

Joy L. Gritton

Student Manuelita Lovato at the Institute of American Indian Arts. (fig.8)

The Institute of American Indian Arts (IAIA), which in 1962 replaced the Santa Fe Indian School's Studio, has been widely credited with revolutionizing and revitalizing modern Indian painting. Encouraged to explode stereotypic expectations while using cultural difference as a basis for creative expression, Institute students' visual vocabulary was strongly bicultural and their works characterized by innovation in technique, style, and subject. The experiment met with an enthusiastic response. There were invitations to exhibit in Washington and to dance at the White House. Students took top honors at national shows. IAIA exhibitions drew large crowds from Berlin to Santiago, while articles lauding the Institute appeared in numerous national periodicals.

The school represented the first attempt in the history of U.S. Indian education to make the arts the central element of the curriculum. The post-Sputnik college preparatory impetus and the G.I. Bill had not been successful in rectifying the disparities which characterized Indian education. In 1961, the year before the Institute enrolled its first students, only sixty-six Indians completed degrees at four-year institutions nation wide. As the arts were perceived as universals which could transcend linguistic and cultural barriers and contribute to a student's sense of accomplishment, the Institute proposed arts training as a means of improving cross-discipline academic performance, while retaining pride in cultural heritage.

Yet, there is overwhelming evidence to support the contention that the Institute was not the cross-cultural refuge it was espoused to be. Those directly responsible for policy and curriculum, such as Director of Indian Education Hildegard Thompson and Institute Director George Boyce, were "old line" Bureau of Indian Affairs (BIA) educators whose concerns rested not so much with the arts as with "getting the country out of the Indian business." Though officially denounced by Secretary of the Interior Fred Seaton as early as 1958, termination continued to enjoy Congressional support until the mid-sixties. "Withdrawal" programs for the Menominee, Choctaw, California Rancheria, Klamath, and the Colville tribes were pending at the beginning of the Kennedy administration, and by 1961 the chairman of the Senate Committee on the Interior and Insular Affairs, Clinton P. Anderson, was advising then Secretary of Interior Stewart Udall to proceed drafting the appropriate legislation with all due speed. Between 1954 and 1960 alone sixty-one tribes, rancherias, allotments, and other groups had been terminated. Correspondingly, President Kennedy's task force on Indian affairs recommended that in Indian education, "emphasis should be placed on training in the management of money, on the importance of saving, and on ways of locating jobs and of adjusting to many aspects of city living."[1]

In keeping with this terminationist strategy, the Institute's curriculum stressed those aspects of art education which administrators felt would ease the transition to an assimilated life style, with course offerings such as "The Artist in Business," "Production," "Sales," and "Advertising Promotion." Students were also coached in "etiquette" and visited Santa Fe homes to observe "family lifestyles." By 1965, the school had implemented an "Apartment Living" course which was required for students in grade 13. Instruction included food purchasing, personal grooming, care of clothing, and "responsible citizenship."

In addition, Director Boyce paid close attention to the students' physical environment, and ordered non-BIA standard furnishings and foods for the

Student Mike Chavarilla with school mosaic. (fig.9)

Institute's living quarters in order that students cultivate "needs" and tastes which would later translate into their adoption of American consumerist habits.

Moreover, Art Director Lloyd New believed it was not possible "for anyone to live realistically while shut in by outmoded tradition," and that the new generation of Indian artists should not resort to a "hopeless prospect of mere remanipulation of the past."[2] Accordingly, the art education theory practiced at the school was one which, as J.J. Brody has suggested, "emphasized the importance of ego satisfaction to the artist,"[3] often in direct conflict with native beliefs. "Traditional" Indian instructors, including Geronima Montoya and Jose Rey Toledo, were dismissed, relinquishing their posts to professional artists considered to be more in tune with "mainstream" trends.

This agenda was established even before the school's conception when art educators, administrators, traders, and artists convened at a Rockefeller Foundation-sponsored conference in 1959 to discuss "Directions in Indian Art." This conference led directly to the establishment of the University of Arizona's Southwest Indian Art Project, held during the summers of 1960-1962, from which the Institute drew much of its art education methodology, as well as several of its faculty members and students. Directed by New and Charles Loloma (who would later marshal the Institute's Department of Plastic Arts), the Project furnished invited participants with room and board and art supplies throughout a succession of lectures, films (including those provided by the Museum of Modern Art), seminars, and workshops.

Discussion at the 1959 conference was focused upon ways to expand the ethnic art market so as to increase the income derived from Indian arts and crafts. The problem of marketing Native arts was multifaceted and complex, and included such factors as competition from mass produced objects, a cash economy which offered better wages for other types of work, and a shift from a Native market to a primarily non-Native one. Moreover, some of the motivations for the promotion of indigenous arts had given rise to a demand for "traditional" items, which obscured the dynamics of Native Americans' past and obliterated any prospect for innovation. Because craft production was viewed as a form of employment which fostered self-esteem and could be carried out in the home, anti-assimilation forces had encouraged the revival and promotion of Indian arts as a way of partially staying the tide of cultural erosion, while providing sorely needed income to reservation communities. For example, Indian rights groups organized in defense of pueblo land claims in the early twenties, such as the Eastern Association on Indian Affairs, the New Mexico Association on Indian Affairs, and the American Indian Defense Association, all listed the support of Indian arts among their projected goals. The School of American Research and the local Chamber of Commerce began sponsoring the Santa Fe Indian Market to this end in 1922. In 1927, such efforts were given official sanction with the release of the Meriam Report, which recommended that the Indian Office coordinate the marketing of Indian "handcrafts," guaranteeing genuineness, quality, and fair prices as a "means to an end; namely, the improvement of the economic and social conditions of life."[4]

These recommendations were realized in part with the formation of the Department of Interior's Indian Arts and Crafts Board (IACB) in 1935.

Inherent in this proposition of Native arts as the economic and social salvation of modern Native American peoples was a predisposition to "preserve," which gave rise to a resistance to change. Activists, collectors, and tourists alike wished to possess only those objects which conformed to their own preconceptions about what constituted Native subject matter, style, or technique. An arbitrary "traditional" ideal was established which was based upon the state of the arts during the initial period of external collecting activity. To further complicate matters, artists often found themselves caught between two principle categories of buyers: collectors and museums, who purchased high quality work, but did not represent an economically significant portion of the total market, and tourists, who typically consumed large numbers of goods, but primarily purchased inexpensive items.

Faced with these considerations, the general consensus which emerged from conference discussion called for a break with tradition and a move from isolation into a more promising modern era. "The future of Indian art lies in the future, not the past," proclaimed New. "Let's stop looking backward for our standards of Indian art production. We must admit that the heyday of Indian life is past, or passing."[5] Citing the promotional and marketing success of certain Scandinavian arts as well as the Indian Arts and Crafts Board, it was suggested that the future of Indian arts lie in new applications of old techniques and skills to meet the demands of new markets. "The Craftsman must make a revision of his own work," explained Loloma. "He must find newer ways of doing things. New forms can come out of Indian backgrounds. People have lots of money, but they have been all over the world and have seen lots of other craft work. It is up to any craftsman to create new things which the buyer cannot resist."[6]

Providing a non-Native, modern context for Indian arts was not a new concept, but rather one which had been championed for more than twenty years by the IACB under Rene d'Harnoncourt's direction. It was a vision first highlighted in d'Harnoncourt's celebrated "Indian Art in the United States and Alaska" exhibition, which was organized for the Golden Gate International Exposition of 1939 under the aegis of the IACB and U.S. Department of Interior, with support from the Carnegie Corporation and the Federal Art Project of the Works Progress Administration. Stating that it was the exhibit's aim "to present to the public a representative picture of the various areas of Indian culture in the United States and Alaska, and at the same time to give the living Indian a chance to find a new market for his products," d'Harnoncourt allocated space within the Federal Building which housed the exhibition to sales rooms and work areas for "Indian artists to demonstrate their skill."[7] Among the demonstrators was a seventeen-year-old Charles Loloma, who painted one of the wall murals of pueblo dances for the Gallery of the Pueblo Cornplanters. As d'Harnoncourt viewed the sales rooms as a "practical laboratory for marketing and merchandising devices," he stressed the decontextualization of Native arts

Kay Weist's commercial art class. (fig.10)

so as to place emphasis on their aesthetic qualities and improve their marketability: "No attention was paid in this shop to tribal origins," d'Harnoncourt explained, "and the articles were grouped in a manner to make the individual pieces appear at their best."[8]

The show met with enthusiastic response and formed the foundation for d'Harnoncourt's highly acclaimed "Indian Art of the United States" exhibition at the Museum of Modern Art in 1941. Subsequently, the exhibition was shown in Mexico City at the National Museum of Anthropology under the auspices of Nelson Rockefeller's Inter-American Office.

D'Harnoncourt's impetus for the transferral of Indian-crafted items out of the trading posts and natural history museums and into the gift shops and art galleries, had, of course, not been conceived in isolation. Native American arts, initially ignored as rude examples of "material culture," had been "discovered" – together with objects deriving from Africa, Oceania, the European peasantry, children, and the insane – by the European art community in the first quarter of the twentieth century. Welcomed into the fold as kindred sheep, objects as diverse as totem poles and kachina masks were rapidly appropriated to serve as both inspiration and affirmation for Post-Impressionist attempts to move from a perceptual to conceptual canon of representation. Moreover, American Indian art came to be touted as the vital root of an untainted, uniquely New World tradition by those critics, scholars, institutions, and artists endeavoring to give shape and form to an independent *American* art. Exhibitions of Native arts sprang up in and about New York (such as the Betty Parson's Gallery 1946 show) which directly asserted the Indian role in the evolution of American culture. Absorbed into a wholly Western fine arts discourse, form took precedence over meaning as the motives and aesthetics of their colonial appropriators were attributed to these Native objects. In this way, "primitive" artists were ironically perceived as modernists ahead of their time–members of a mythic universal family of enlightened painters and sculptors uncorrupted by Western civilization – as the introduction to the 1931 Exposition of Indian Tribal Arts reveals:

> *The Indian artist deserves to be classed as a Modernist, his art is old, yet alive and dynamic, but his modernism is an expression of a continuing vigour seeking new outlets and not, like ours, a search for release from exhaustion.... He is a natural symbolist. He is bold and versatile in the use of a line and colour. His work has a primitive directness and strength, yet at the same time it possesses sophistication and subtlety. Indian painting is at once classic and modern.*[9]

Robbed of their content, indigenous arts were now free to be judged on an "equal" footing with their Western counterparts: in other words, they could be evaluated solely by Euro-American criteria.

It remained, however, for those attending the Rockefeller conference to call for the next step in the continuum of colonization of indigenous art production–the de-tribalization of the creators of the arts themselves. Admitting that the Indian artist could not be repackaged as simply as his product, several speakers nevertheless remained firm in their conviction that a deep-seated transformation in the relationship between artist and culture was required if Indian arts were to survive and flourish in the modern era. Andreas Andersen, Chairman of the Art Department at the University of Arizona, warned that while "the transition between the Indian-artist and the artist will not be easy," it was nevertheless crucial to "force" new forms:

> *In order to produce a valid art product, the Indian artist must face the choice of one of two alternatives: either to try to keep his work within the tradition, or to disregard the tradition.*
> *Unfortunately the results in the first direction have become stereotyped*

or confused by meaningless repetitions. Artistic quality has been lost and fewer and fewer true artists have developed. In the second case the tradition is lost; no tradition can be preserved when the conditions which fostered it are in change. We do the Indian no service by trying to impede or prevent change because of a sort of nostalgia.[10]

Robert Quinn, Associate Professor of Art at the University of Arizona, went on to summarize prevailing conference sentiments with the announcement:

> *It is important for the Indian to realize that being an artist is a matter of being an individual. In many cases tribal customs inhibit this, but I am convinced that only an individually creative approach can bring about a growth in art produced by the Indians.... It seems to me that the real problem the Indian artist faces is the insistence that he be an Indian. He should be an Indian only if he simply cannot help it. To dwell too much on his Indianism is to put the emphasis on ethnology rather than art.... His only alternative is to become a museum piece himself.*[11]

The dangerous implication here was that traditional aesthetics – distinguished by concern for communal welfare, social mores, and religious proscriptions and practices – and thus, traditional values and beliefs, were dysfunctional and inimical to success in the modern world. In order to attain their fullest potential, both Indian art <u>and</u> artist must be kept distinct from "ethnology." Thus, one of the prime new "Directions in Indian art" was to be a move toward "universal," namely Western, aesthetic value at the expense of cultural context.

This course, set during the Rockefeller Conference and pursued at the Southwest Indian Art Project, found its most concrete implementation at the Institute. While the school carefully constructed a public image of unfettered, culturally pluralistic arts training, the Institute's curriculum and a reward system introduced by competitive exhibitions promoted a distinctly non-Native artistic and political agenda. Cultural pluralism came to be defined as the adaptation and distillation of the students' traditional heritage into forms palatable to modernism. In studio classes students were encouraged to visually convey only the "essence" of their Indianness. The primary criterion for inclusion of their work in the school's major touring exhibition of 1966-68 was that it be "new directional" – demonstrating innovation in style, technique or media– although a "traditional" source was also to be readily evident. That exhibition, which toured four continents and represented the U.S. at the Edinburgh Festival, the Berlin Festival, and the 1968 International Olympics in Mexico City, like other Institute shows, was not representative of the breadth of art being produced at the school. For example, in Josephine Wapp's "Traditional Techniques" course, students were still making the "traditional" source objects of sinew, hide, beads, and shell, and in the painting studios, students were still creating tempera landscapes and domestic scenes reminiscent of Dorothy Dunn's Studio. Significantly, such works continue to languish in the school's Honors Collection.

The "matter of being an individual," of which Quinn spoke, held even more far reaching connotations for the American art community in the Spring of 1959, however. Amidst a post-war atmosphere characterized by heady nationalism, nuclear terror, and Red hysteria, modern art had come to be heralded by its proponents as the epitome of individual choice in the free world. "It is obvious that the dilemma of our time cannot be solved by a denial of experimentation whether by directive or by pressure," wrote d'Harnoncourt in 1948, then vice-president of foreign activities for the Museum of Modern Art. "It can be solved," he continued, "only by an order which reconciles the freedom of the individual with the welfare of society and replaces yesterday's image of one unified civilization by a pattern in which many elements, while retaining their own

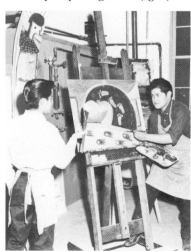

Students Franklin Martinez and Roger Tsabetsaye in painting studio. (fig.11)

individual qualities, join to form a new entity.... I believe a good name for such a society is democracy, and I also believe that modern art in its infinite variety and ceaseless exploration is its foremost symbol."[12] Thus, the exportation of American individualism through the vehicle of New York style modernism became the tack of a federally- and privately-funded operation led primarily by the Rockefeller Foundation, but supported also by other foundations, such as that of the Carnegies. Known as the "cultural cold war," its aim was to export "cultural excellence" in the interest of global political and economic influence. Serge Guilbaut has perceptively pointed out the far reaching implications of the new Western offensive:

IAIA student at work in drawing class. (fig.12)

> *Once American culture was raised to the status of an international model, the significance of what was specifically American had to change: what had been characteristically American now became representative of "Western culture" as a whole. In this way American art was transformed from regional to international art and then to universal art.... In this respect, postwar American culture was placed on the same footing as American economic and military strength: in other words, it was made responsible for the survival of democratic liberties in the "free world."*[13]

The Museum of Modern Art assumed primary responsibility for distribution and promotion of American arts abroad after 1956, modeling its "International Program" after earlier contract work for the Inter-American Affairs Office. In 1959, the year of the "Directions in Indian Art" Conference, the MoMA's *New American Painting* exhibition was touring Europe. These Museum of Modern Art/Rockefeller activities cannot be seen as unrelated to the patronage of, and interest in, the Conference, the Southwest Indian Art Project, and the Institute of American Indian Arts. For, significantly, Indian art could now be promoted as both reassuringly modern, as well as uniquely American.

Within this framework, the probability of true artistic and intellectual exchange at the school became doubtful. Why, then, has the Institute's success story of innovative minority education, revised federal Indian policy, and revolutionized Native arts remained largely unchallenged in the popular and scholarly literature? The school's enigmatic reputation has been colored by the special interests which it has served. First, there is little doubt that this experiment in cross-cultural education was perceived as having great potential for demonstrating American leadership in the resolution of racial discrimination and economic repression. Five years before the founding of the school, the Supreme Court had mandated desegregation with the landmark Brown vs. the Board of Education decision. Civil rights sit-ins had begun by 1960, and in 1961, as Institute Director Boyce was first arriving in Santa Fe, Freedom Riders were being brutally beaten in the South. The year of the Institute's opening federal troops were on the campus of the University of Mississippi to ensure the registration of James Meredith, that institution's first African American.

Sparks of the fire to come were being ignited in Indian Country as well. As early as 1958, Iroquois "activists" clashed with state troopers and riot police in New York. Indian college students throughout the Southwest had been holding conferences since 1954 and by 1961 had formed the National Indian Youth Council, which would play an instrumental role in the marches and "fish-ins" of the early sixties. The American Indian Chicago Conference, which brought together Native American leaders concerned about the survival of tribalism in the face of federal termination policy, was also held in 1961.

Clearly, amidst this atmosphere, there were sufficient political benefits to be reaped from the establishment of an education facility which prided itself on its acceptance, indeed, celebration, of "cultural difference." The Institute's intended role as a model of education and social reform was explicitly outlined in the school's original Basic Statement of Purpose:

IAIA dance troupe performs at the White House. (fig.13)

A key aim is to present to people of the world – in Asia, Africa, Europe and South America – an American educational program which particularly exemplifies respect for a unique cultural minority.

To the extent that these aims are accomplished, the Institute of American Indian Arts may become a prototype of a practical operating center for upgrading the role of the American Indians in contemporary society. Thus, in many ways, the Institute of American Indian Arts carries the responsibility of being something new in human affairs of potentially great significance.[14]

It is not surprising, therefore, that the Institute frequently served as host to State Department visitors, particularly foreign dignitaries from Africa, and that the school's only White House performance was for President and Mrs. Yemeogo of Upper Volta. Likewise, it seems hardly coincidental that James McGrath, Arts and Crafts Director for American Dependent Schools in Europe and North Africa, was chosen for the Institute's post of Assistant Director of the Arts. McGrath's extensive connections abroad were to prove invaluable in orchestrating a series of foreign exchanges.

A demystification of the Institute's role in training a disproportionate number of the country's leading contemporary Indian artists, then, raises questions regarding cultural imperialism, the marketing of ethnicity, and Native artistic autonomy in the formal evolution and ideological underpinnings of recent modern Indian art. Although considerable attention has been paid to the school's efforts to widen a tightly reigned art market and explode stereotypical artistic limitations, the ideological underpinnings of those efforts, and the attempt to undermine Native beliefs and teachings which they represented, have not been explored.

Much of the critique of Indian education in general has focused upon what Katherine Iverson terms the moral and political issue of "civilization" and the economic issue of "assimilation."[15] While the pedagogical practices of the Institute encompassed each of these, the school's very existence, and its subsequent degree of financial and political support, have been irretrievably enmeshed in political and economic issues which reach far beyond the boundaries of Indian policy to global issues tangential, at best, to Native American welfare.

The school offered an innovative approach to an old theme. Under the guise of cross-cultural education, students would be taught their tribal histories and cultures and, at the same time, would be encouraged to leave them behind for modern conveniences, more acceptable "manners," and an enlightened and more promising artistic milieu. Vine Deloria has insightfully pointed out the underlying premise of such tactics:

> *The transition of recent federal policy from termination to self-determination reflects only a tactical shift in the fundamental commitment of the society to bring Indians into the mainstream, not a movement toward a true recognition of a permanent tribal right to exist.*[16]

Thus, sadly, the Institute in many respects conformed to a colonial educational system model, addressing foremost the needs of the dominant society. Within such a model education represents an alien institution designed, as Philip Altbach and Gail Kelly have suggested, to "fit people into a world different from the one in which their parents lived and work," regardless of whether or not indigenous languages are employed in instruction, indigenous culture is emphasized in the curriculum, or other adaptations are made to the culturally distinct student body. Such education has little, if any, relevance to life and work within the indigenous community, does not allow for the input of parents, and is conducted in isolation from the students' home.[17]

In the Institute's deliberate effort to "liberate" students' behavior and artistic endeavors from cultural restraints much was lost: traditional art education imparted not only knowledge of the group's designs, techniques, and media, but also the meanings embodied in each. Artistic proficiency included the intellectual and philosophical, as well as the visual and tactile. For, within a culturally and pedagogically autonomous society, all education functions as a socialization process which serves to transmit the knowledge, skills, values, and beliefs of a culture from one generation to the next. The Institute, though highly acclaimed for its attempt at culturally pluralistic arts training, in fact, had an antithetic intent – an intent to incite cultural change, to effect a colonization of the mind facilitated by the arts.

[1] Brophy and Aberle, *The Indian: America's Unfinished Business; Report of the Commission of the Rights, Liberties and Responsibilities of the American Indian*, 115.

[2] New, "Cultural Difference as the Basis for Creative Education," *Native American Arts*, 1 (1968):8.

[3] Brody, *Indian Painters & White Patrons*, 198.

[4] Schrader, *The Indian Arts and Crafts Board*, 17-20.

[5] Dockstader, ed., *Directions in Indian Art*, 28.

[6] Ibid., 26.

[7] United States Department of the Interior, Indian Arts and Crafts Board, *Indian Art in the United States and Alaska: A Pictorial Record of the Indian Exhibition at the Golden Gate International Exposition*.

[8] Ibid.

[9] Sloan and LaFarge, *Introduction to American Indian Art*, 6.

[10] Dockstader, ed., *Directions in Indian Art* 13.

[11] Ibid., 16.

[12] D'Harnoncourt, "Challenge and Promise: Modern Art and Modern Society," *Magazine of Art* 41, no. 7 (November, 1948): 252.

[13] Guilbaut, *How New York Stole the Idea of Modern Art*, trans. Arthur Goldhammer, 174.

[14] The Institute of American Indian Arts, *A Basic Statement of Purpose*.

[15] Iverson, "Civilization and Assimilation in the Colonialized Schooling of Native Americans," in *Education and Colonialism*, 153.

[16] Philip, ed., *Indian Self-Rule: First Hand Accounts of Indian White Relations from Roosevelt to Reagan*, 193.

[17] Altbach and Kelly, eds., *Education and Colonialism*, 3-4.

Color Plates 1-76

Plate 1. CARL SWEEZY (Arapaho) b.1881-d.1953
"Indians Fighting White Men," pre 1942 housepaint on board, 30.5 x 96.5 cm.

Plate 2. ERNEST SPYBUCK (Shawnee) b.1883-d.1949
"Shawnee War Dance," n.d. watercolor on paper, 50.8 x 88.9 cm.

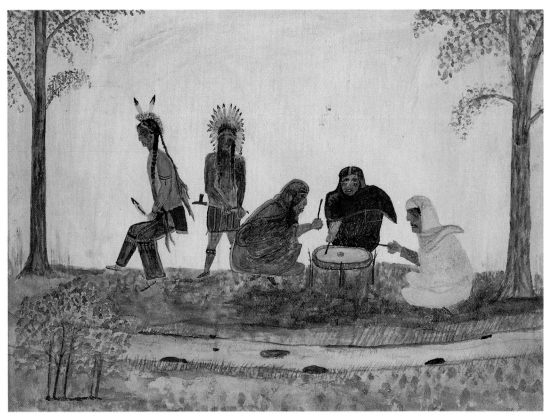

Plate 3. CRESENCIO MARTINEZ (San Ildefonso) b.unknown-d.1918
"Taos Dancers," c.1900 watercolor on paper, 38.3 x 50 cm.

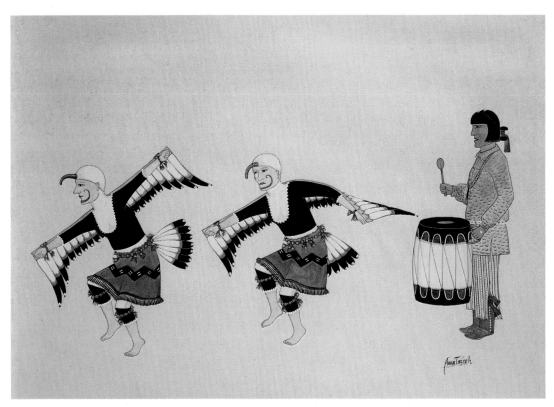

Plate 4. AWA TSIREH/ALFONSO ROYBAL (San Ildefonso) b.1898-d.1955
"Eagle Dance," 1930 watercolor on paper, 28 x 35.5 cm.

Plate 5. JULIAN MARTINEZ (San Ildefonso) b.1897-d.1943
"Pottery Design," n.d. watercolor on paper, 52 x 65 cm.

Plate 6. TONITA PEÑA/QUAH AH (San Ildefonso) b.1895-d.1949
Untitled, 1939 watercolor on paper, 45.7 x 50.8 cm.

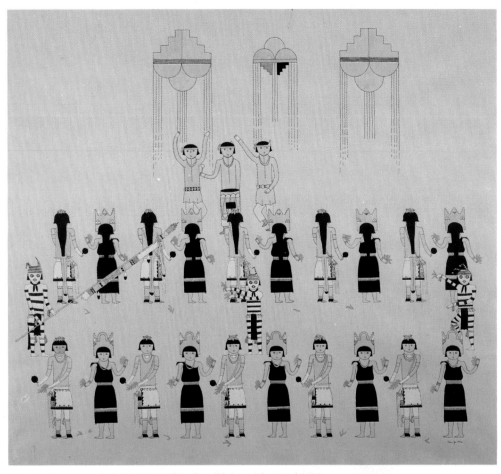

Plate 7. TSE YE MU/ROMANDO VIGIL (San Ildefonso) b.1902-d.1978
Untitled, n.d. watercolor on paper, 81.3 x 86.4 cm.

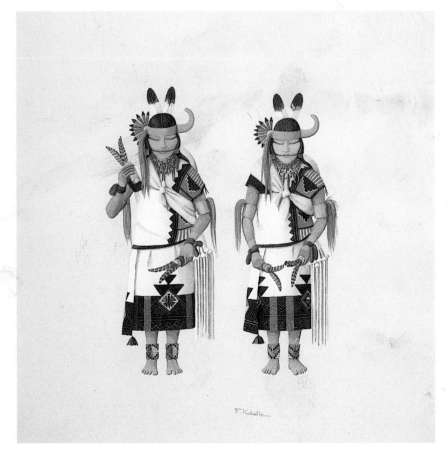

Plate 8. FRED KABOTIE (Hopi) b.1900-d.1986
"Lakonmanat (Lakon Maidens)," c.1930-35 casein and watercolor on paper, 32.5 x 35.7 cm.

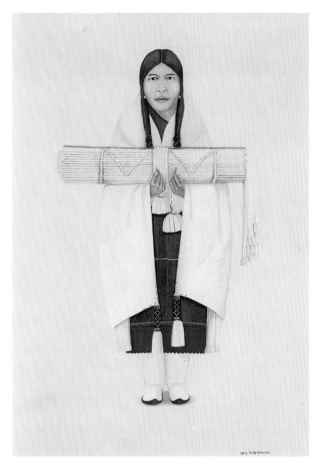

Plate 9. OTIS POLELONEMA
(Hopi) b.1902-d.1981
"The New Bride Woman," c.1930
watercolor on paper, 48.5 x 30.5 cm.

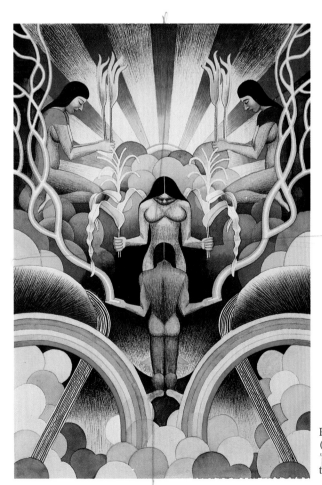

Plate 10. WALDO MOOTZKA
(Hopi) b.1903-d.1938
"Pollination Of The Corn," 1948
tempera on paper, 46.7 x 35 cm.

Plate 11. POP CHALEE/MARINA LUJAN HOPKINS (Taos) b.1908
"Enchanted Forest," n.d. watercolor on paper, 48.5 x 63.8 cm.

Plate 12. PABLITA VELARDE/TSE TSAN (Santa Clara) b.1918
"The Betrothal," 1953 tempera on canvas board, 55.5 x 71 cm.

Plate 13. QUINCY TAHOMA (Navajo) b.1921-d.1956
"First Furlough," 1943 watercolor on paper, 45.5 x 38 cm.

Plate 14. HARRISON BEGAY (Navajo) b.1917
"Squaw Dance," n.d. tempera on paper, 78.7 x 96.5 cm.

Plate 15. ANDREW TSINNAJINNE (Navajo) b.1916
"Slayer Of Enemy Gods-Nayeinezani," c.1962
tempera on watercolor board, 77.7 x 51 cm.

Plate 16. GILBERT ATENCIO (San Ildefonso) b.1930
"Basket Dance," 1962 watercolor on paper, 47.3 x 64 cm.

Plate 17. BEATIEN YAZZ/JIMMY TODDY (Navajo) b.1928
"Gallup Ceremonial Parade," c.1946 poster colors on board, 57.5 x 72.5 cm.

Plate 18. HA SO DA/
NARCISO ABEYTA
(Navajo) b.1918
"Changeable Wolf Man,"
1958 casein on paper,
77 x 56 cm.

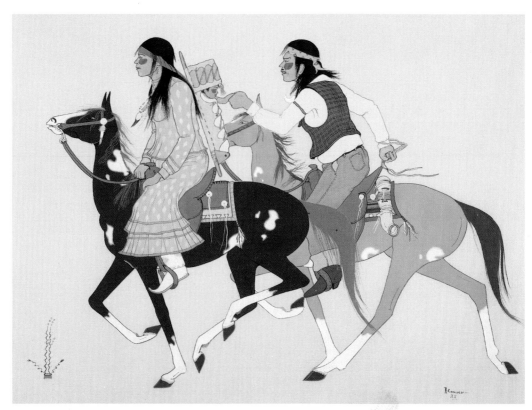

Plate 19. ALLAN HOUSER (Chiricahua Apache) b.1915
"Apache Family," 1938 tempera on paper, 30.5 x 39.7 cm.

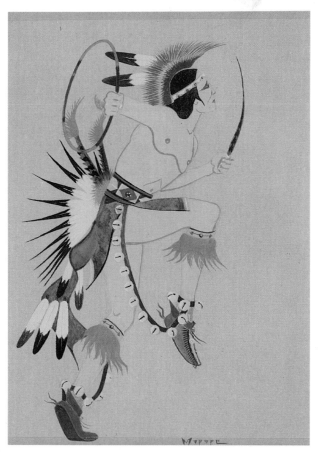

Plate 20. STEPHEN MOPOPE (Kiowa) b.1898-d.1974
Untitled, n.d. watercolor on paper, 38.1 x 27.9 cm.

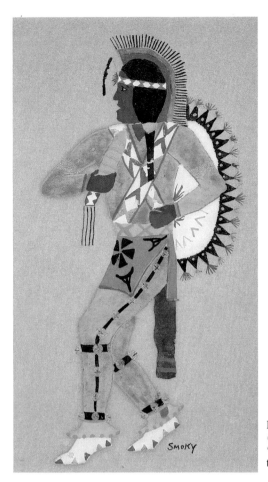

Plate 21. LOIS SMOKEY/BOUGETAH
(Kiowa) b.1907-d.1981
"Dancing Warrior," n.d.
tempera on paper, 14 x 8.5 cm.

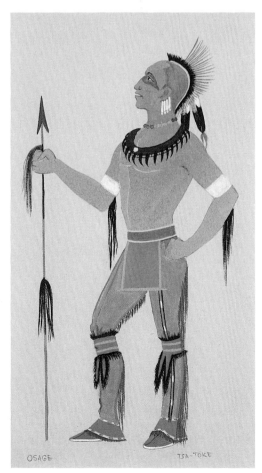

Plate 22. MONROE TSATOKE/TSA TO KEE
(Kiowa) b.1904-d.1937
"Osage Warrior," n.d.
tempera on paper, 34.5 x 24.8 cm.

Plate 23. JACK HOKEAH (Kiowa) b.1902-d.1973
"Portrait of an Indian Man," n.d.
tempera on paper, 22.7 x 14.5 cm.

Plate 24. JAMES AUCHIAH (Kiowa) b.1906-d.1975
"Kiowa Funeral," 1930 opaque watercolor on paper, 23 x 36.5 cm.

Plate 25. SPENCER ASAH (Kiowa) b.1905-d.1954
Untitled, n.d. watercolor on paper, 22.8 x 17.7 cm.

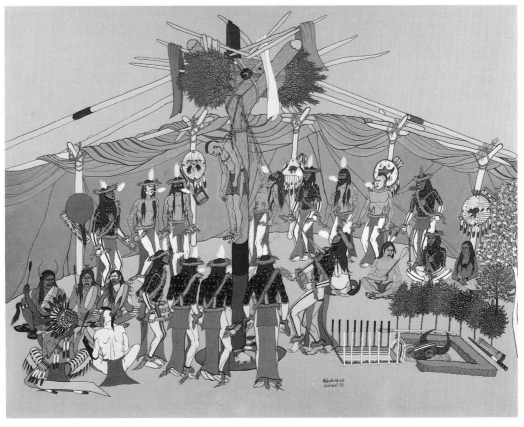

Plate 26. W. RICHARD WEST (Cheyenne) b.1912
"Southern Cheyenne Sun Dance Or The Great Medicine Lodge Ceremony," 1973
watercolor on paper, 80 x 101.5 cm.

Plate 27. ACEE BLUE EAGLE (Creek/Pawnee) b.1907-d.1959
"The Deer Spirit," c.1950 watercolor on board, 53.3 x 45.7 cm.

Plate 28. BLACKBEAR BOSIN (Kiowa/Comanche) b.1921
"Of The Owls Telling," 1965 gouache on illustration board, 94 x 81 cm.

Plate 29.
WOODROW WILSON "WOODY" CRUMBO
(Creek/Potawatomi) b.1912-d.1989
"Eagle Dancer," n.d.
tempera on paper, 91 x 75 cm.

Plate 30. JOAN HILL
(Creek/Cherokee) b.1930
"Creek White Feather Dance," 1962
watercolor on paper, 96.5 x 63.5 cm.

Plate 31. FRED BEAVER (Creek) b.1911-d.1980
"The Orator," 1973 tempera on paper, 45.5 x 61 cm.

Plate 32. C. TERRY SAUL (Choctaw/Chickasaw) b.1921
"Tree Of Jesse," 1968 watercolor on paper, 91.5 x 61.3 cm.

Plate 33. CECIL DICK (Cherokee) b.1915
"Cherokee Burial," 1973 tempera on paper, 57 x 77 cm.

Plate 34. VALJEAN HESSING (Choctaw) b.1934
"Choctaw Removal," 1966 watercolor on paper, 21.5 x 55 cm.

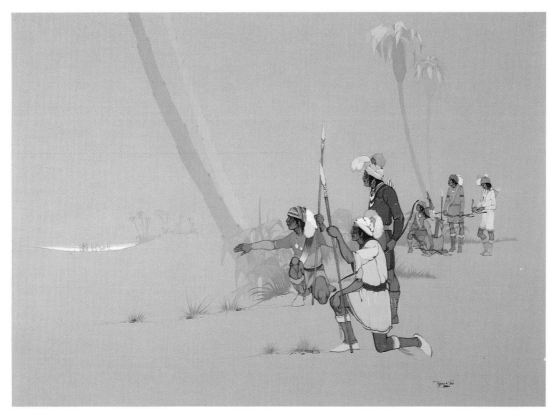

Plate 35. JEROME TIGER (Creek/Seminole) b.1941-d.1967
"The Intruders," 1966 casein on poster board, 40.6 x 50.8 cm.

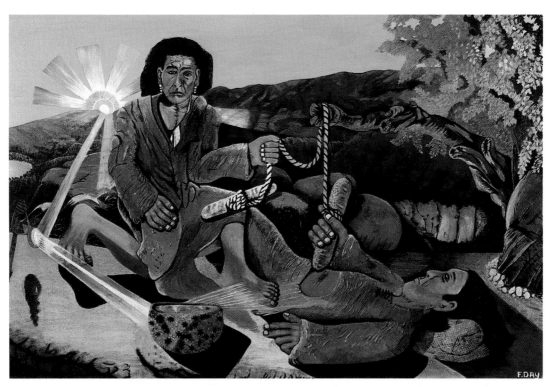

Plate 36. FRANK DAY (Maidu) b.1902-d.1976
"Ishi And Companion At Iamin Mool," n.d. oil on canvas, 61 x 91 cm.

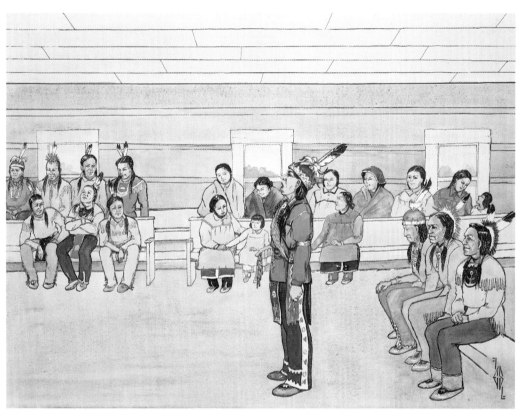

Plate 37. ERNEST SMITH (Seneca) b.1907-d.1975
"The Doctrine Of Handsome Lake," 1969 ink and watercolor on illustration board, 38 x 50.8 cm.

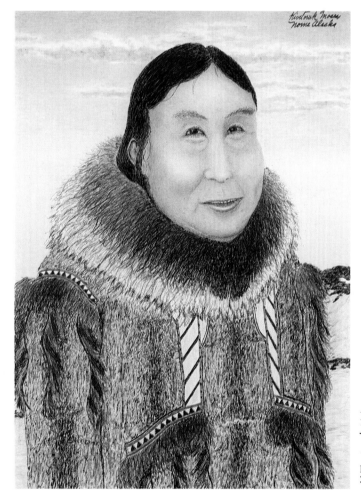

Plate 38.
JAMES MOSES/KIVETORUK
(Eskimo) b.1900-d.1982
"Old Time Eskimo Belle," c.1963
pen and ink with colored pencils,
30.5 x 22.5 cm.

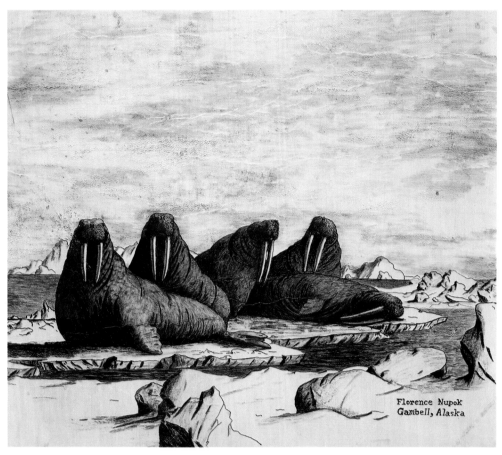

Plate 39. FLORENCE NUPOK CHAUNCEY/MALEWOTKUK (Eskimo) b.1906-d.1971
"Walrus," 1957 pen and ink on seal skin, 29.5 x 34 cm.

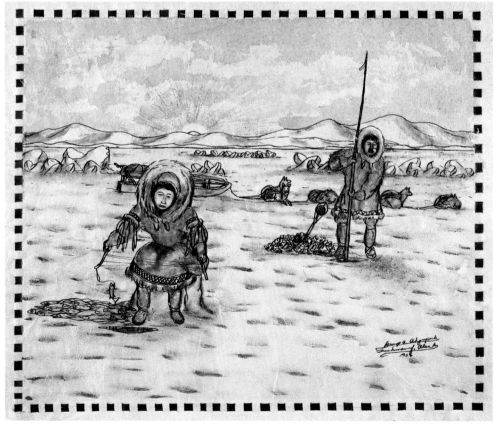

Plate 40. GEORGE A. AHGUPUK (Eskimo) b.1911
Untitled, n.d. pen and ink on reindeer skin, 30 x 25.3 cm.

Plate 41. OSCAR HOWE (Yanktonai Sioux) b.1915-d.1983
"Ghost Dance," 1960 watercolor on paper, 45.7 x 60.9 cm.

Plate 42. JOE HERRERA (Cochiti) b.1923
"Spring Ceremony for Owah," 1983 watercolor on paper, 73.7 x 94 cm.

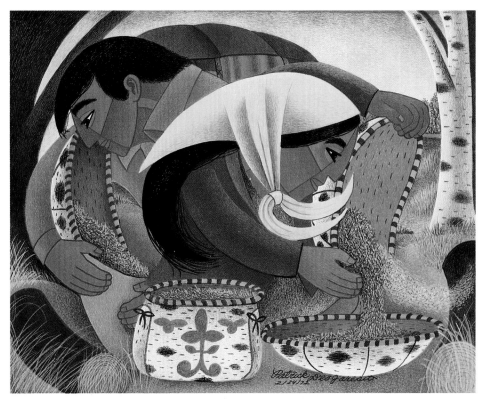

Plate 43. PATRICK DesJARLAIT (Chippewa) b.1921-d.1973
"Gathering Wild Rice," c.1971 watercolor on paper, 27.8 x 39.5 cm.

Plate 44. GEORGE MORRISON (Ojibway) b.1919
"The White Painting," 1971 acrylic on canvas, 115 x 152.5 cm.

Plate 45. HELEN HARDIN (Santa Clara) b. 1943-d.1984
"Recurrence of Spiritual Elements," 1973
acrylic on masonite, 83.8 x 66 cm.

Plate 46. MICHAEL KABOTIE (Hopi) b.1942
"Petrogylphs," 1967 casein on paper, 38.1 x 50.8 cm.

Plate 47. MARY MOREZ
(Navajo) b.1938
"Study Of A Navajo Woman," 1969
Conté crayon on paper,
63.5 x 53.3 cm.

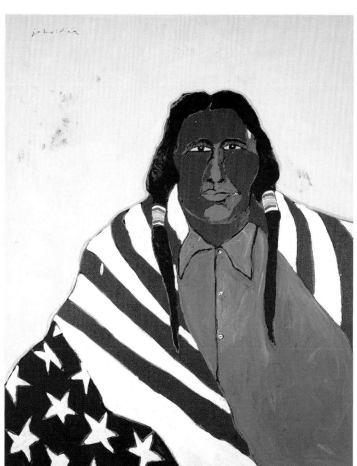

Plate 48. FRITZ SCHOLDER
(Luiseño) b.1937
"Indian Wrapped In Flag," c.1976
acrylic on canvas, 172.5 x 137 cm.

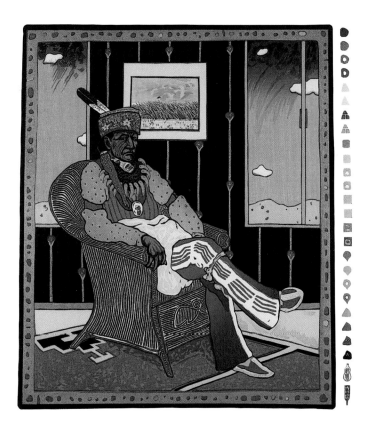

Plate 49. T.C. CANNON
(Caddo/Kiowa) b.1946-d.1978
"Osage With Van Gogh
or *Collector #5,"* c.1980
woodcut after painting by the
same title (25/200), 64 x 51 cm.

Plate 50. R.C. GORMAN
(Navajo) b.1932
"Navajo Woman," 1973
watercolor on paper,
73 x 58.5 cm.

Plate 51. LINDA LOMAHAFTEWA
(Hopi/Choctaw) b.1947
"New Mexico Sunset," 1978
acrylic on canvas, 130 x 104 cm.

Plate 52. GEORGE LONGFISH
(Seneca/Tuscarora) b.1942
"Spirit Guide/Spirit Healer," 1983
acrylic on paper, 101.6 x 76.2 cm.

Plate 53.
JAUNE QUICK-TO-SEE SMITH
(Cree/Flathead/Shoshone) b.1940
"Rain," 1990 mixed-media,
A: 203 x 76 cm.
B: 29.1 x 29.2 cm.
C: 30 x 30.5 cm.

Plate 54. HARRY FONSECA
(Maidu/Portuguese/Hawaiian) b.1946
*"When Coyote Leaves The Reservation
(a portrait of the artist as a young Coyote),"*
1980 acrylic on canvas, 122 x 91.5 cm.

Plate 55. JAMES LAVADOUR (Walla Walla) b.1951
"New Blood," 1990 oil on linen, 46 x 234 cm.

Plate 56. KAY WALKINGSTICK (Cherokee) b.1935
"Uncontrolled Destiny," 1989 acrylic, oil, and wax on canvas (diptych), 91.5 x 183 cm.

Plate 57. WILLARD STONE (Cherokee) b.1916
"Young Rabbit Hawk," 1968 wood, 45.7 x 12.7 x 10.2 cm.

Plate 58. JOHN JULIUS WILNOTY (Cherokee) b.1940
"Up From The Deep," 1971 catlinite, 34.5 x 34 x 17 cm.

Plate 59. DUFFY WILSON
(Tuscarora/Iroquois) b.1925
"ToDoDaHo," 1973
stone, 17 x 24 x 29 cm.

Plate 60. JOHN HOOVER
(Aleut) b.1919
"Shaman In Form Of An Eagle," 1973
polychrome wood, 223 x 100 x 20 cm.

Plate 61. ALLAN HOUSER(Chiricahua Apache) b.1915
"Sheltered," 1979 bronze, 38.1 x 15.2 x 10.2 cm.

Plate 62. GEORGE MORRISON (Ojibway) b.1923
"Chiringa Form, Small #1," 1987
purple heart and padouk wood, 25.5 x 20 x 10 cm.

Plate 63. BOB HAOZOUS
(Apache/Navajo/English/Spanish)
b.1943
"Ozone Madonna," 1989
painted mahogany and steel,
145 x 52.5 x 30 cm.

Plate 64. LARRY BECK
(Yup'ik) b.1938
*"Poonka Timertik Inua
(Punk Walrus Spirit),"* 1987
mixed-media, 47 x 28 x 31.5 cm.

Plate 65. TRUMAN LOWE
(Winnebago) b.1944
"Mnemonic Totem #3," 1989
bronze, 120 x 25 x 25 cm.

Plate 66. ROXANNE SWENTZELL (Santa Clara) b.1962
"The Emergence Of The Clowns,"
 1988 coiled and scraped clay,
A: 58.4 x 33 x 33 cm.
B: 43.2 x 55.9 x 45.7 cm.
C: 43.2 x 35.6 x 35.6 cm.
D: 17.8 x 48.3 x 26 cm.

Plate 67. R.E. BARTOW (Yurok) b.1946
"Salmon Mask," 1987 mixed-media, 45.7 x 30.5 x 20.3 cm.
photo credit : Alfred Jacobs

Plate 68. RIC DANAY (Mohawk) b.1942
"Coast To Coast and See To Sea," 1981 mixed-media, 25.3 x 38.2 x 7 cm. Side **A.**

Plate 69. RIC DANAY (Mohawk) b.1942
"Coast To Coast and See To Sea," 1981 mixed-media, 25.3 x 38.2 x 7 cm. Side **B.**

Plate 70. HARRY FONSECA (Maidu/Portuguese/Hawaiian) b.1946
"Magic Box #2," 1990 mixed-media, 90 x 163 x 65 cm. Side **A.**

Plate 71. HARRY FONSECA (Maidu/Portuguese/Hawaiian) b.1946
"Magic Box #2," 1990 mixed-media, 90 x 163 x 65 cm. Side **B.**

Plate 72. BOB HAOZOUS (Apache/Navajo/English/Spanish) b.1943
"The Abortionist's Bed," 1990 cut steel, 2.22 x 1.07 x 2.22 m.

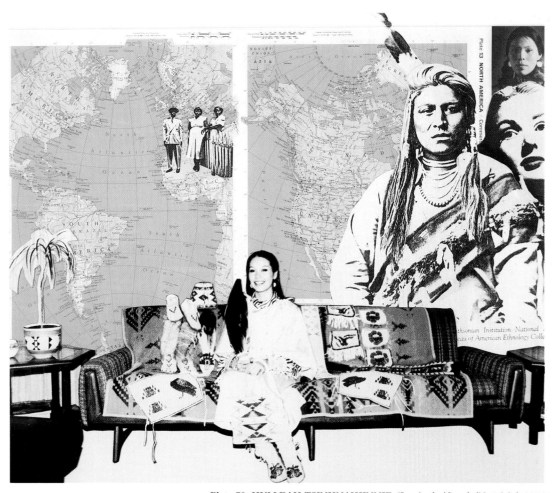

Plate 73. HULLEAH TSINHNAHJINNIE (Seminole/Creek/Navajo) b.1954
"When Did Dreams of White Buffalo Turn to Dreams of White Women,"
1990 photo collage, 63 x 73.5 cm.

Plate 74. JAMES LUNA (Luiseño/Diegueño) b.1950
"The Creation and Destruction of an Indian Reservation," 1990
video and mixed-media installation, 6.1 x 2.4 m.

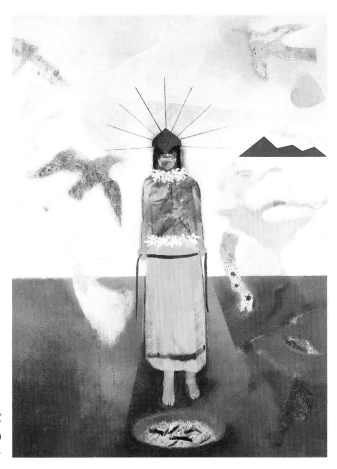

Plate 75. FRANK LAPENA
(Nomtipom Wintu) b.1937
"Earth Mother (Red Cap)," 1990
acrylic on canvas, 121.5 x 91.5 cm.

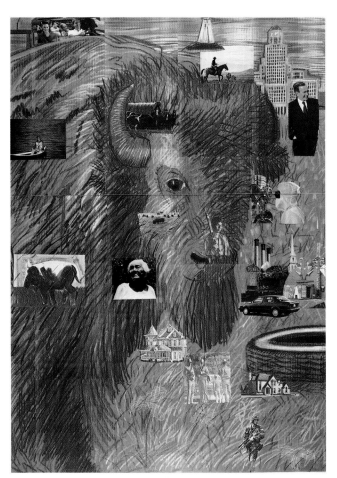

Plate 76. G. PETER JEMISON
(Seneca) b.1945
"Buffalo Road III–Choice," 1990
mixed-media, 121.9 x 152.4 cm.

In the mid 1800s, a group of Native American artists began painting personal experiences and interpretations of tribal history. The subject matter reflected the rapid changes occurring in the Indian Territory, especially during the late 1800s and early 1900s. The artists in this group were mainly self-taught and painted in a stylistically Naive manner that was full of detail. The works are important ethnographic documents. But they are also important because they represent a time before Indian artists were limited to painting what was to be defined by outsiders as "Indian." Of this group, Carl Sweezy and Ernest Spybuck were the first to consider themselves American Indian professional artists. Sweezy and Spybuck painted what was in their hearts. They painted because they were artists, and this, along with being Indian, could not be separated from their lives.

CARL SWEEZY
(Arapaho) b.1881-d.1953

Born: near Darlington, Oklahoma
Education: No formal art training

"A true artist needs plenty of space in which to think and to create."
C. Sweezy, c.1930[1]

"Indians Fighting White Men," pre 1942
[OHS.80.82.29]
watercolor on paper, 30.5x96.5 cm.
(color plate 1)

Historic events from the Indian perspective are evident in this painting of the battle of Little Big Horn and the defeat of General Custer by the Indians.

"Peyote Road Man," c.1927
[HM.IAC2367]
house paint and pencil on board,
69.6x39.4 cm. (fig.15)

The attention to the details of Peyote religious paraphernalia depicted in this painting is characteristic of this period. The rigid frontal pose is reminiscent of the Euro-American portrait photography popular at the turn of the century.

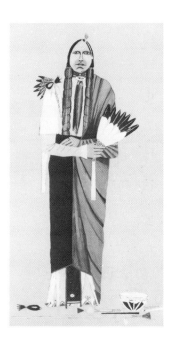

"General View Of The Arapaho, Sun Dance Lodge, 1890," n.d. [GM.0127.2089]
house paint on board, 94x186 cm. (fig.16)

In addition to depictions of daily life, the Narrative Genre style includes the documentation of ceremonial life.

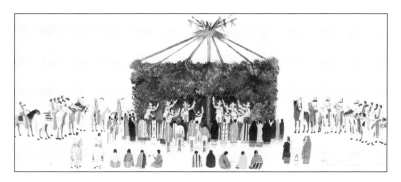

"Indian On Horse," pre 1952 [OHS.80.82.31]
watercolor on paper, 46x34.5 cm. (fig.14)

This three-quarter view of the horse and his rider illustrates the natural approach to perspective that the early American Indian artists used prior to the institutionalization of "Indian" art.

ERNEST SPYBUCK

(Shawnee) b.1883-d.1949

Born: near Tecumseh, Oklahoma
Education: No formal art training

"Mother Earth started me drawing..."
E. Spybuck, c.1900[2]

"Shawnee War Dance," n.d. [HM.IAC2269]
oil on canvas, 50.8x88.9 cm.
(color plate 2)

In *"Shawnee War Dance,"* Spybuck depicts the sacred along with the secular. Around the edge of the gathering, groups of people meet to watch and to visit with one another. Spybuck's attention to the details of clothing, shelter, and transport captures the blending of non-Indian and Native cultures at the turn of the century.

"Shawnee Home About 1890," c.1910 [NMAI.2.5785]
watercolor on paper, 44.2x62.2 cm. (fig.18)

This genre painting is evidence of Spybuck's importance as a bridge between the past and the present. His paintings were literally slices-of-life.

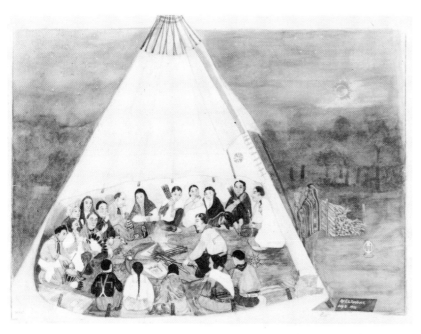

"Peyote Tipi," 1938 [HM.IAC2270]
watercolor on paper, 78.7x58.4 cm. (fig.17)

Spybuck used a "window" technique to allow the viewer to experience the events inside and outside simultaneously. The technique also established the time of day and season of each event depicted. Spybuck used this format throughout his career.

"Kickapoo Cowboys," c.1930 [OHS.LP3178]
watercolor on paper, 51x68.5 cm. (fig.19)
.

This watercolor and pencil painting is a fine example of Spybuck's remarkable talent as an artist. He once told the anthropologist M.R. Harrington that his favorite subjects were cowboys, cattle, and ranch scenes.

By 1900, numerous artists were working in a medium and style that would come to be defined as "Traditional" Indian painting. The activity began at the Pueblo of San Ildefonso, New Mexico. It quickly spread to the other pueblos, influencing future generations of Native painters. The San Ildefonso Watercolor Movement began with the depiction of the dances, everyday activities of the pueblo culture, and pottery designs executed in the watercolor medium. The patrons for these small paintings were mainly anthropologists, teachers at federal Indian schools, and wealthy, influential "friends" whose personal interest in Southwest Native culture brought them in contact with the artists. This patronage played a major role in the Movement's stylistic development.

CRESENCIO MARTINEZ

(San Ildefonso) b.unknown-d.1918

Born: San Ildefonso Pueblo, New Mexico
Education: No formal art training

"Taos Dancers," c.1900 [Private Collection]
watercolor on paper, 38.3x50 cm.
(color plate 3)

In this early painting, Martinez depicted background and foreground. The absence of these elements has often been a defining stylistic component of Traditional Indian painting as a "natural" approach by Indian artists to the non-Indian art form. Thus, the frequent inclusion of these elements by the early artists, before the influences of their patrons, brings this theory into question.

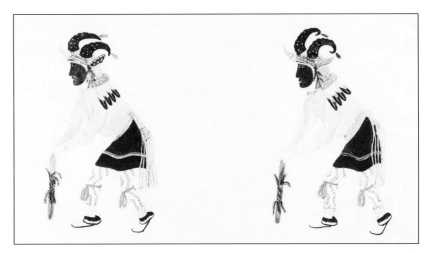

"Mountain Sheep Dance," 1918 [SAR.P20]
watercolor on paper, 36x57 cm. (fig.20)

The hallmark of the San Ildefonso Watercolor Movement was the depiction of the dances.

AWA TSIREH/
ALFONSO ROYBAL

(San Ildefonso) b.1898-d.1955

Born: San Ildefonso Pueblo, New Mexico
Education: No formal art training

"Eagle Dance," 1930 [SAR]
watercolor on paper, 28x35.5 cm.
(color plate 4)

Awa Tsireh's personal stylistic approach included both naturalistic and highly stylized renderings of traditional dancers. In later years, his work was peppered with humor.

"San Ildefonso Girls Firing Pottery," c.1919 [MNM]
watercolor on paper, 28x35.5 cm. (fig.21)

Awa Tsireh painted many versions of this common pueblo activity. One version includes the use of three-point perspective. However, the popularity of paintings that excluded background and foreground was instrumental in the development of the Movement.

JULIAN MARTINEZ
(San Ildefonso) b.1897-d.1943

Born: San Ildefonso Pueblo, New Mexico
Education: No formal art training

"Pottery Design," n.d. [GM.0236.257]
watercolor on paper, 52x65 cm.
(color plate 5)

Martinez is best known for the pottery designs he painted for his wife, the internationally known potter, Maria Martinez. He transferred these elaborate pottery designs to the medium of watercolor on paper in which he created elegant, elaborate, and sophisticated forms.

TONITA PEÑA/QUAH AH
(San Ildefonso) b.1895-d.1949

Born: San Ildefonso Pueblo, New Mexico
Education: No formal art training

Untitled, 1939 [HM.IAC539]
watercolor on paper, 45.7x50.8 cm.
(color plate 6)

This later painting by Peña commemorated the Coronado Cuatro Centennial. The priest is centrally located and slightly raised in the picture plane. He is depicted with his arm raised, blessing the tribal leaders that surround him. The painting is reminiscent of European subject matter, specifically, French artist Eugene Delacroix's depiction of "Liberty Leading the People." Peña may have been influenced by military recruitment posters in the Albuquerque and Santa Fe areas which used this image from the French Revolution.

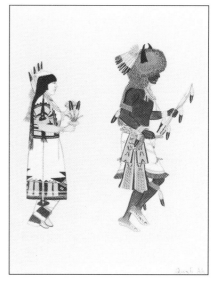

"Buffalo Dance," n.d.
[Private Collection]
watercolor on paper, 29.5x39.5 cm. (fig.22)

Peña was the only woman painter working during this early period. Prior to this time, Native women primarily produced and ornamented utilitarian art, such as pottery. Her work reflects the perspective of a pueblo woman. She painted dances and activities in which women were the participants. Peña's pioneering work made it possible for other Indian women to work in this art form.

TSE YE MU/ROMANDO VIGIL
(San Ildefonso) b.1902-d.1978

Born: San Ildefonso Pueblo, New Mexico
Education: No formal art training

Untitled, n.d. [HM.IAC2281]
watercolor on paper, 81.3x86.4 cm.
(color plate 7)

Tse Ye Mu perfected a stylized design approach to illustrating ceremonial dances, permitting the representation of sacred images in a secular format. Stylized images and simplicity of line made Tse Ye Mu a leader within the San Ildefonso Watercolor Movement.

The spread of the San Ildefonso Watercolor Movement to the other pueblos and to other tribes in the region produced the Southwest Movement, which is exemplified by the high degree of technical development and prominence of individual artists and their personalities. At the same time, however, a dogma of Traditional Indian painting was developing through the institutionalization of Indian art instruction by the federal government. Patronage of wealthy individuals and government-supported programs speeded development of a commercial market for the fine art. This economic support was a factor in the development of Indian painting competitions, mural projects, and the inclusion of Indian art in world fairs held during this time in the Americas.

FRED KABOTIE
(Hopi) b.1900-d.1986

Born: Shungopovi, Second Mesa, Arizona
Education: Santa Fe Indian School, New Mexico; private art classes with Mrs. J.D. De Huff, Santa Fe, New Mexico

"*Lakonmanat (Lakon Maidens)*," c.1930-35
[IACB.68.56.30]
casein and watercolor on paper,
32.5x35.7 cm. (color plate 8)

This work is an excellent example of Kabotie's skill as an artist. The figures are floated in the picture plane, devoid of background or foreground. Yet, Kabotie's modeling of form, shading, and detailed texturing add volume and a three-dimensional quality that brings the dancers to life.

"*The Delight Makers*," c.1940
[NMAI.23.1268]
watercolor on paper, 50.5x61 cm. (fig.24)

This scene of a pueblo plaza filled with dancers and spectators is an example of the standard by which Traditional Indian painting was measured. The standard was set by Kabotie and his contemporaries.

"*Butterfly Water Drinking Dance*," 1925
[HM.IAC26]
watercolor on paper, 30.4x53.3 cm. (fig.23)

Kabotie is probably the best known artist of this period. His talent and the support of wealthy patrons brought Traditional Indian painting into a "golden age" of appreciation and respect.

"*Clowns Getting Ready*," post 1950
[CAL.ACAD.370-1215]
tempera on paper, 51x37.5 cm. (fig.25)

This work shows Kabotie's stylistic development. He dramatizes the images with an absence of line, as well as the use of color and spatial relationships.

OTIS POLELONEMA
(Hopi) b.1902-d.1981

Born: Shungopovi, Second Mesa, Arizona
Education: Santa Fe Indian School, New Mexico

"I will tried [sic] my very best to do the work, but only I don't know how to paint flat work. How will it be if I do the shade work? If not let me know."
O. Polelonema, May 27, 1938

"The New Bride Woman," c.1930
[CAL.ACAD.370-1129]
watercolor on paper, 48.5x30.5 cm.
(color plate 9)

Polelonema, along with Fred Kabotie, established the "Hopi" style of painting. Polelonema's delicate treatment of form and exacting depiction of details captured the strength of Hopi life and established conventions that other artists were expected to follow.

WALDO MOOTZKA
(Hopi) b.1903-d.1938

Born: Oraibi, Third Mesa, Arizona
Education: Santa Fe Indian School, New Mexico

"Fertility Symbols," n.d. [GM]
tempera on paper, 46.7x35 cm.
(color plate 10)

Mootzka's most popular series of paintings had fertilization themes. The influences of European Art Deco style, popular during the 1920s, and the erotic treatment of the subject matter were radical innovations that distinguished Mootzka as a pioneer in the evolution of the Traditional Indian painting style. Mootzka's singular effort to break from the Traditional style may have been a signal to future artists.

POP CHALEE/MARINA LUJAN HOPKINS
(Taos) b.1908

Born: Castle Gate, Utah
Education: The Studio, Santa Fe Indian School, New Mexico

"Enchanted Forest," n.d. [HM.IAC347]
watercolor on paper, 48.5x63.8 cm.
(color plate 11)

Chalee has been credited with using elements of her multi-cultural heritage in her art. It is probably more accurate to say that she has created a distinctly personal style that combines stylized pueblo motifs with Art Deco and which has been influenced by her East Indian heritage. Chalee has also been credited with creating the Indian "Bambi" style of painting. This refers to her mystical, wide-eyed, and multi-colored renderings of animals, such as blue deer with sharply pointed hooves and horses with great sweeping manes and tails.

PABLITA VELARDE/TSE TSAN
(Santa Clara) b.1918

Born: Santa Clara Pueblo, New Mexico
Education: The Studio, Santa Fe Indian School, New Mexico; studied with Tonita Peña

"The Betrothal," 1953 [Private Collection]
tempera on canvas board, 55.5x71 cm.
(color plate 12)

Continuing the legacy of Tonita Peña, Velarde's main subjects are related to life-styles of pueblo women. "The Betrothal" is a fine example of Velarde's treatment of subject and of her approach to design. The interior space is done with a three-point perspective, that focuses on the central image of the "groom," balanced by the "bride" and the "elder." The entire space is used to depict the families and "guests" as they gather around to witness the ceremony. Velarde is a role model for many young Native women artists, including her daughter, Helen Hardin, who made her own mark on the Native Fine Art Movement.

QUINCY TAHOMA
(Navajo) b.1921-d.1956

Born: Tuba City, Arizona
Education: The Studio, Santa Fe Indian School, New Mexico

"First Furlough," 1943 [NMAI.23.6014]
watercolor on paper, 45.5x38 cm.
(color plate 13)

In "First Furlough," Tahoma depicted what was a common sight on reservations across the country as young Native American men enlisted in the military during World War II. A tradition of military service has been a part of Native America since before citizenship was granted in 1925.

HARRISON BEGAY
(Navajo) b.1917

Born: White Cone, Arizona
Education: The Studio, Santa Fe Indian School, New Mexico

"Squaw Dance," n.d. [HM.IAC422]
tempera on paper, 78.7x96.5 cm.
(color plate 14)

Begay is probably the best known Navajo artist of the Southwest Movement. He is also considered one of the most successful artists of The Studio style of painting. Begay's figures are flat areas filled in with bright colors. The figures are uniform and are not individual portraits. His depiction of Navajo life is filled with warmth and a gentle humor.

ANDREW TSINNAJINNE
(Navajo) b.1916

Born: Rough Rock, Arizona
Education: Santa Fe Indian School, New Mexico

"Slayer Of Enemy Gods-Nayeinezani," c.1962 [Private Collection]
tempera on watercolor board, 77.7x51 cm.
(color plate 15)

The commercialization of Indian art was most evident in the increased number of Indian art contests in the Southwest. This painting won first prize in the 1962 Scottsdale National Indian Art Show, Scottsdale, Arizona.

GILBERT ATENCIO
(San Ildefonso) b.1930

Born: Greeley, Colorado
Education: Santa Fe Indian School, New Mexico

"Basket Dance," 1962 [HM.IAC735]
watercolor on paper, 47.3x64 cm.
(color plate 16)

One of the most versatile artists of his generation, Atencio has developed many stylistic approaches to his art that range from abstraction to realistic portrait-like figures. In "Basket Dance," each of the dancers is an individual in contrast to the repeated design images of earlier Southwest watercolor paintings.

BEATIEN YAZZ/JIMMY TODDY/LITTLE NO SHIRT
(Navajo) b.1928

Born: near Wide Ruins, Arizona
Education: Santa Fe Indian School, New Mexico; The Art Institute of Chicago, Illinois; Mills College, Oakland, California

"Gallup Ceremonial Parade," c.1946 [SAR.1985.7]
poster colors on board, 57.5x72.5 cm.
(color plate 17)

According to Yazz, this painting was completed while he was in Oakland, California. The Gallup Intertribal Indian Ceremonial is one of the largest Indian gatherings in the United States.

HA SO DA/NARCISO ABEYTA
(Navajo) b.1918

Born: Cañoncito, New Mexico
Education: Santa Fe Indian School, New Mexico; Somerset Art School, Williamsburg, Pennsylvania; B.F.A., University of New Mexico, Albuquerque

"I stuck with my own style of painting. I think what I concentrate on most is color."
Ha So Da/N. Abeyta, Nov. 19, 1989[4]

"Changeable Wolf Man," 1958
[CAL.ACAD.370-7]
casein on paper, 77x56 cm.
(color plate 18)

The wolfman subject is a popular image in Navajo mythology. Abeyta frequently chose subjects from Navajo mythology for his paintings. In 1960, a similar painting won an award at the Gallup Intertribal Indian Ceremonial.

"Rain And Hail," n.d. [MNM.1740]
casein on paper, 46x64.5 cm. (fig.26)

Abeyta was a student of Raymond Jonson at the University of New Mexico, along with Joe Herrera.

"Shaking Pollen From The Corn," n.d.
[SAR.P312]
watercolor on paper, 35.5x30.5 cm. (fig.27)

"There was a period when they took my paintings and dumped them somewhere–didn't even put them up. It was very discouraging."
Ha So Da/N. Abeyta, June 8, 1984[5]

ALLAN HOUSER

(Chiricahua Apache) b.1915

Born: Apache, Oklahoma
Education: Haskell Indian College, Law-
rence, Kansas; Santa Fe Indian School,
New Mexico; studied mural technique with
Olaf Nordmark at Fort Sill, Oklahoma

"Apache Family," 1938 [OU.AM]
tempera on paper, 30.5x39.7 cm.
(color plate 19)

The influences of The Studio can be seen in
this small painting. The flat areas of soft
color contrast with the careful outlining of
the figures.

"Apache Crown Dance," 1953 [DAM, Gift of
Margaret Davis, and Cornelia and Josephine
Evans]
casein on paper, 63.5x93.9 cm. (fig.28)

The illustrative qualities of the Southwest
Movement are seen in Houser's depiction
of Apache Crown dancers.

"The Wild Horses," 1953 [HM.IAC4]
opaque watercolor on paper, 55.8x93.9 cm.
(fig.29)

This painting is rendered in The Studio
style while displaying a monumental feel
for the depiction of a wild horse roundup.
The utilization of the entire picture plane is
similar to the Southwest mural tradition.

During the early 1900s, a number of young Kiowa artists was "discovered" by Susie Peters, a Field Matron for the Kiowa Agency in Anadarko, Oklahoma. Peters encouraged the young artists and introduced them to O.B. Jacobson, a member of the art faculty at the University of Oklahoma in Norman. Although varied in technical skill, these artists, as a group, established the Oklahoma style of Indian painting. The elegant, dramatic rendering of movement distinguishes the Oklahoma style from the more sedate Southwest style. This Oklahoma style, combined with the Southwest style, defined Traditional Indian painting and has had a major influence on generations of Indian artists. As the popularity of these painting styles grew and the pressures of the market increased, the quality began to deteriorate, as is evident in later paintings by many of these artists.

STEPHEN MOPOPE
(Kiowa) b.1898-d.1974

Born: near Red Stone Baptist Mission, the Kiowa Reservation, Oklahoma
Education: special non-credit art courses at University of Oklahoma, Norman

Untitled, n.d. [HM.IAC2277]
watercolor on paper, 38.1x27.9 cm.
(color plate 20)

Drama and movement, delicately illustrated in this watercolor, were the hallmark of the Oklahoma style.

"The Procession," n.d. [PAC.58.20]
watercolor, 48.5x61.5 cm. (fig.30)

Execution of subject matter, horizontal placement, and bands of perspective in this painting reflect the approach taken by the Kiowa artists in the development of mural cartoons. The emphasis on murals as a medium can be seen in their paintings. During the 1930s, the federal government actively supported mural projects by American Indian artists. There is little documentation about the actual murals, which were sponsored by the Works Progress Administration (WPA) and the Public Works Administration (PWA).

LOIS SMOKEY/BOUGETAH
(Kiowa) b.1907-d.1981

Born: Anadarko, Oklahoma
Education: special non-credit art courses at the University of Oklahoma, Norman

"Dancing Warrior," n.d.
[Private Collection]
tempera on paper, 14x8.5 cm.
(color plate 21)

Smokey was the only woman artist of this early period of Oklahoma style painting. She studied with the group and was active as an artist for only a brief time. The exact period of activity is not known.

MONROE TSATOKE/
TSA TO KEE
(Kiowa) b.1904-d.1937

Born: Saddle Mountain, Oklahoma
Education: special non-credit art courses at
the University of Oklahoma, Norman

"Osage Warrior," n.d. [GM.963]
tempera on paper, 34.5x24.8 cm.
(color plate 22)

This small watercolor has the monumental
quality seen in the mural figures of the
Kiowa artists.

JACK HOKEAH
(Kiowa) b.1902-d.1973

Born: on the Kiowa reservation in western
Oklahoma
Education: special non-credit art courses at
the University of Oklahoma, Norman; Santa
Fe Indian School, New Mexico

"Portrait of an Indian Man," n.d.
[GM.0227.176]
tempera on paper, 22.7x14.5 cm.
(color plate 23)

This portrait is not characteristic of the
usual full figure presentation of the Kiowa
paintings.

JAMES AUCHIAH
(Kiowa) b.1906-d.1975

Born: Medicine Park, Oklahoma
Education: special non-credit art courses at
the University of Oklahoma, Norman

"Kiowa Funeral," 1930
[CAL.ACAD.370.1248]
opaque watercolor on paper, 23x 36.5 cm.
(color plate 24)

Auchiah captures the drama of the Okla-
homa style in this painting.

SPENCER ASAH
(Kiowa) b.1905-d.1954

Born: Carnegie, Oklahoma
Education: special non-credit art courses at
the University of Oklahoma, Norman

Untitled, n.d. [HM.IAC765]
watercolor on paper, 22.8x17.7 cm.
(color plate 25)

A series of pochoir portfolios was published
by C. Szwedzicki in Nice, France, with text
by O.B. Jacobson. The prints were based on
dance images painted by Asah and other
members of the Kiowa group while at the
University of Oklahoma.

Out of the success and popularity of the Kiowa artists and the Southwest Movement, a painting tradition representative of the Plains cultures within Oklahoma was born. In 1935, an art program was established at Bacone Junior College in Oklahoma. The founding director of the department was Acee Blue Eagle who was succeeded by Woodrow Wilson (Woody) Crumbo and W. Richard (Dick) West. These three painters chaired the art department for a period of thirty-five years and influenced countless Native American artists. The Bacone Period can be defined stylistically as using complex design elements in a decorative manner to "romance" the past. The mythology was presented with a sense of the theatrical and the mysterious. The popularity of this style continues today throughout the United States and Canada.

W. RICHARD WEST
(Cheyenne) b.1912

Born: near Darlington, Oklahoma
Education: Bacone Junior College, Bacone, Oklahoma; B.A. and M.F.A., University of Oklahoma, Norman; University of Tulsa, Oklahoma; University of Redlands, California; mural instruction under Olaf Nordmark, Phoenix, Arizona

"There will always be Indian art because of the color of skin. But without exposure to the old culture, it's like a non-Indian trying to paint Indian."
W. R. West, July 23, 1986[6]

"Southern Cheyenne Sun Dance Or The Great Medicine Lodge Ceremony,"
1973 [Private Collection]
watercolor on paper, 80x101.5 cm.
(color plate 26)

West has experimented with many artistic styles, ranging from Realistic to Abstract.

"Wolf Dance," c. 1940 [OU.AM]
tempera on paper, 50.7x33.2 cm. (fig.31)

This early painting is a fine example of West's skill and understanding of the watercolor medium.

"Cheyenne Winter Games," n.d. [PAC.51.14]
watercolor on paper, 51x66 cm. (fig.32)

West's interest in documenting his tribal traditions is represented in this painting of winter activities. The entire tribe participated in activities, such as hand-ball, football, "snow snake," shinny, arrow throwing, wrestling, top throwing, ice fishing, sledding, tobogganing, and gambling.

ACEE BLUE EAGLE
(Creek/Pawnee) b.1907-d.1959

Born: Wichita Reservation, north of
Anadarko, Oklahoma
Education: Bacone Junior College, Bacone,
Oklahoma; Oxford University, England;
University of Oklahoma, Norman; University of Tulsa, Oklahoma

"The Deer Spirit," c.1950 [HM.IAC1952]
watercolor on board, 53.3x45.7 cm.
(color plate 27)

Blue Eagle was perhaps the most renowned
of all the Oklahoma Indian artists. He was
a dynamic figure in the art world and one of
the most flamboyant and sought after artists of his generation. Blue Eagle used his
culture and his personality to promote his
art.

BLACKBEAR BOSIN
(Kiowa/Comanche) b.1921

Born: near Anadarko, Oklahoma
Education: No formal art training

*"We all have adopted a responsibility, ...to
our people,...to the art world, in depicting as
accurately as possible the ways, the customs,
attitudes and dogmas of our fore fathers...
(who) guide our thinking and our hands in
creating the things we do..."*
Blackbear Bosin, 1976[7]

"Of The Owls Telling," 1965 [IACB]
gouache on illustration board, 94x81 cm.
(color plate 28)

This painting was commissioned by the
Indian Arts and Crafts Board, U.S. Department of the Interior. Bosin's depiction of a
warrior's vision-quest is dramatic in form
rather than movement. Bosin's highly theatrical, almost cinematic, adaptation of traditional painting dominated much of Indian
art in the immediate post-World War II era.

WOODROW WILSON "WOODY" CRUMBO
(Creek/Potawatomi) b.1912-d.1989

Born: Lexington, Oklahoma
Education: University of Oklahoma, Norman; studied mural techniques with Olaf
Nordmark, Phoenix, Arizona

*"Give him the opportunity and the Indian
will create things of beauty such as the world
has never seen."*
W.W. Crumbo, December 7, 1952[8]

"Eagle Dancer," n.d. [GM.593]
tempera on paper, 91x75 cm.
(color plate 29)

Crumbo's paintings continue the Kiowa
tradition of brilliantly colored and animated
dancers. However, he transcends the early
Kiowas with his knowledge of the watercolor medium. His skilled layering of paint
becomes almost transparent, making the
colors more vivid. The figures' movements
become almost erotic in their dance poses.

"Ducks at Night," n.d. [HM.IAC1029]
etching (1/100), 10.1x15.2 cm. (fig.33)

In 1952, Crumbo opened a print studio in
Taos, New Mexico. The studio was developed for the purpose of producing an Indian art product that the general public
could afford and that provided for the economic development of Indian artists and
tribes. His efforts and promotion of the
print media as acceptable venues for Indian
art may well be his greatest contribution to
the Native American Fine Art Movement.

"The Hunter," n.d. [HM.IAC1037]
etching (1/100), 10.1x15.2 cm. (fig.34)

Before 1830, the Seminole, Chickasaw, Creek, Choctaw, and Cherokee People of what is now Georgia, Mississippi, Alabama, and the Carolinas, had adopted many of the trappings of "civilization." They were plantation owners, newspaper publishers, and elected county officials. Their move to Oklahoma in the 1830s, which is referred to as "The Trail of Tears," stemmed from the conflict between the tribes and the desire of states to control the lives of the "Civilized Tribes."

The art of the Five Civilized Tribes reflects the culture of the Southeast. Stylistically, the artists have incorporated soft pastel colors characteristic of the Southwest Movement with a moderately dramatic subject matter that is somewhat less theatrical than that of the Bacone Period.

JOAN HILL
(Creek/Cherokee) b. 1930

Born: Muskogee, Oklahoma
Education: Muskogee Junior College, Oklahoma; B.A., Northeastern University, Tahlequah, Oklahoma; studied with W. Richard West at Bacone Junior College, Bacone, Oklahoma

"Art widens the scope of the inner and outer senses and enriches life by giving us a greater awareness of the world."
J. Hill[9]

"Creek White Feather Dance," 1962
[HM.Galbraith Collection]
watercolor on paper, 96.5x63.5 cm.
(color plate 30)

One of the few Native women artists of her generation to become successful, Hill has mastered the transition from Traditional Indian painting to Contemporary Indian painting that had its beginnings in the 1960s.

FRED BEAVER
(Creek) b. 1911-d. 1980

Born: Eufaula, Oklahoma
Education: Bacone Junior College, Bacone, Oklahoma; Haskell Indian Institute, Lawrence, Kansas

"I wanted to change the non-Indian's image of my people, and I wanted to help my own people understand themselves, especially the young. So I sketched and painted the scenes from my childhood..."
F. Beaver, November 29, 1970[10]

"The Orator," 1973 [HM.IAC2330]
tempera on paper, 45.5x61 cm.
(color plate 31)

Throughout his career, Beaver illustrated the historic lifestyles of the Creek and Seminole people. This painting is more static than work of the Bacone Period. Yet, the use of shading of a single color on the black paper is dramatic and captures the power of the moment. Beaver's hallmark was his use of monochromatic color.

C. TERRY SAUL
(Choctaw/Chickasaw) b.1921-d.1976

Born: Sardis, Oklahoma
Education: Bacone Junior College, Bacone,
Oklahoma; B.F.A. and M.F.A., University
of Oklahoma, Norman; Art Students League,
New York, New York

*"Each painting should be a departure from
the one before. You've got to keep improving
and growing. An artist cannot afford to
become stagnant."*
C.T. Saul[11]

"Tree Of Jesse," 1968 [HM.RS.94S2.7]
watercolor on paper, 91.5x61.3 cm.
(color plate 32)

Saul developed a personal style using mini-
mal color and heavy dark lines that almost
appear to be silhouettes of the images. The
figures become light and float in the picture
plane creating a ghostly, other-worldly qual-
ity in his paintings.

CECIL DICK
(Cherokee) b.1915

Born: Rose, Oklahoma
Education: Bacone Junior College,
Bacone, Oklahoma; The Studio, Santa Fe
Indian School, New Mexico

"Cherokee Burial," 1973 [HM.RS.170.S2.12]
tempera on paper, 57x77 cm.
(color plate 33)

Dick's extensive knowledge of Cherokee
culture is demonstrated in his art. The
monumental quality of his painting shows
the influence of The Studio.

VALJEAN HESSING
(Choctaw) b.1934

Born: Tulsa, Oklahoma
Education: Mary Hardin-Baylor College,
Belton, Texas; Tulsa University,
Oklahoma

"Choctaw Removal," 1966 [PAC.]
watercolor on paper, 21.5x55 cm.
(color plate 34)

Indian removal became a frequently de-
picted event with the establishment of the
annual "Trail of Tears" exhibit. The exhibit
is sponsored by the Cherokee Historical
Center in Tahlequah, Oklahoma.

JEROME TIGER
(Creek/Seminole) b.1941-d.1967

Born: Tahlequah, Oklahoma
Education: Cleveland Art Institute, Ohio

"The Intruders," 1966 [NMAI]
casein on poster board, 40.6x50.8 cm.
(color plate 35)

Tiger was one of the most popular of the
younger generation of Oklahoma artists.
His delicately rendered paintings were pow-
erful, if sometimes sad, interpretations of
Oklahoma Indian history.

The continuation of the Narrative Genre style of the Native American Fine Art Movement can be found in the varied regions of Northern California, Upper New York State, and Alaska. These artists depict stories, both common everyday events and sacred histories. The artists are self-taught, and their paintings are powerful personal and cultural records. For the most part, these artists have been overlooked and unknown outside of their regions. This lack of recognition resembles that of the Early Narrative Genre artists who were dismissed as "interesting but not significant" artists by the "experts." Ironically though, this Narrative Genre style may well be the "true" Indian style of painting because these artists were not dominated by outsiders or the art market. Rather, they produced art for their personal satisfaction and for the good of their communities. The production of art for the good of the community is the "Indian" in Indian art and not technique or style.

FRANK DAY
(Maidu) b.1902-d.1976

Born: Berry Creek, Butte County, California
Education: No formal art training

"...I talk my paintings, say them, sing them, and then paint them..."
F. Day[12]

"Ishi And Companion At Iamin Mool," n.d.
[Private Collection]
oil on canvas, 61x91 cm.
(color plate 36)

As a youngster, Day and his father witnessed this scene. Sensing their intrusion on a private and urgent situation involving strangers, Day and his father observed from afar. A second encounter occurred at the Oroville jail, where "Ishi, the last wild Indian in North America," was being held in custody after his capture. There was an instant recognition from the trail incident. But they did not speak the same language, and no verbal communication could be established.

"Mourning At Mineral Springs," n.d.
[Private Collection]
oil on canvas 61x91 cm. (fig.36)

When Frank Day was born, his father was sixty years old. Day's father shared with his son the ways of his generation and the stories of earlier generations. Frank Day became the bridge to the past for younger generations of California Natives.

"Whirlwind At Bloomer Hill," n.d.
[Private Collection]
oil on canvas, 60.5x76.2 cm. (fig.35)

Day's knowledge of the old ways made him a vital link to the revitalization movement taking place among northern California tribal cultures. Many young California Native artists participated in this movement during the early 1960s.

"Punishment Tree," n.d. [Private Collection]
oil on canvas, 45.7x61 cm. (fig.37)

"This painting illustrates a special form of punishment once used to restrain recalcitrant women. The offender is shown lashed to the 'punishment tree' for some rebellious action and will remain there until she repents. If she fails to regret her transgression, she will suffer the further punishment of having two fingers broken backwards, an injury which will be carried as a scar for the rest of her life."
F. Day, [13]

ERNEST SMITH

(Seneca) b.1907-d.1975

Born: Tonawanda Reservation, New York
Education: No formal art training

"The Doctrine Of Handsome Lake," 1969
[IACB.W70.4.10]
ink and watercolor on illustration board,
38x50.8 cm.
(color plate 37)

In response to forced assimilation and the
pressures of Christian missionaries to put
aside the "pagan" religions of their ancestors, the words of the prophet, Handsome
Lake, became a unifying voice for the Seneca people. Since that time, the Doctrine
of Handsome Lake has been recited and
passed on to future Seneca generations.

"Seven Brothers," c.1969
[Private Collection]
oil on canvas, 46x61 cm. (fig.38)

Smith was well know for his paintings of
ancient legends. This oil painting illustrates the Seneca story of the creation of
the Big and Little Dippers.

"Carving The False Face," 1969
[IACB.W70.4.12]
ink and watercolor on illustration board,
38x51 cm. (fig.39)

Smith's mastery of his medium is evident in
this finely executed watercolor painting.

JAMES MOSES/KIVETORUK

(Eskimo)

b.1900-d.1982
Born: near Cape Espenberg, Alaska
Education: No formal art training

*"I'm not [a] good artist, but I have more
experience..."*
J. Kivetoruk[14]

"Old Time Eskimo Belle" c. 1963
[CAL.ACAD.370-1018]
pen and ink with colored pencils,
30.5x22.5 cm. (color plate 38)

This depiction of an Eskimo woman, resplendent in her stylish parka, is thought to
be a portrait of the artist's wife, Bessie.
Moses took up drawing and painting while
recuperating from injuries sustained in a
plane crash in 1953.

*"Eskimo Celebration Dance At The End Of
World War II,"* 1962 [IACB.W63.5.1]
ink and watercolor with colored pencils on
poster board, 31.5x44.3 cm. (fig.40)

Moses' paintings are based on people and
events from real-life situations. His skill in
rendering the texture of the frozen tundra
and melting snow is captured through his
brush strokes.

"Eagle With Man," c. 1963
[CAL.ACAD.370-1021]
pen and ink with colored pencils,
44.3x31.7 cm. (fig.41)

The image of Tin-mi-uk-puk soaring high
above the earth, an Eskimo grasped in his
huge talons, is pure Moses: direct, engaging, and uncomplicated. The variegated
pastel colors are ever present in his paintings, as is his attention to detail.

"Polar Bear Sneaking Behind Walrus," n.d.
[MNM.1813]
mixed-media, 31.7x44.5 cm. (fig.42)

Moses was not formally trained in art. His
drawing reflects an acute sensitivity to his
surroundings and suggests the coldness of
the ice and water. His animals were anatomically correct while his renderings of
the human form were naive, with little attention to accuracy.

The Alaskan Movement, which began in the early twentieth century, was closely allied to mainstream American art styles of Naive and Genre painting. The narrative paintings and drawings were lighthearted and depicted the ordinary. The Alaskan Movement has been virtually ignored because of the powerful impact of the commercial printing that institutionalized Eskimo art.

FLORENCE NUPOK CHAUNCEY/MALEWOTKUK
(Eskimo) b.1906-d.1971

Born: Village of Gambell, Saint Lawrence Island, Alaska
Education: No formal art training

"Walrus," 1957 [CAL.ACAD.370-993]
pen and ink on seal skin, 29.5x34 cm.
(color plate 39)

In September, walrus herds congregate on slow-moving ice fields to sleep. This arctic landscape of sea and ice is dominated by five huge walruses on an ice floe. Three walruses gaze directly at the viewer while one looks off into the distance, watchful. Another walrus rests secure in the company of sentries. Nupok's skilled renderings earned her the title, "Grandma Moses of the Bering Sea."

GEORGE A. AHGUPUK
(Eskimo) b.1911

Born: Shishmaref, Seward Peninsula, Alaska
Education: No formal art training

Untitled, n.d. [NMAI.19.1655]
pen and ink on reindeer skin, 30x25.3 cm.
(color plate 40)

Ahgupuk was one of the first Eskimo artists to gain a reputation as a fine art artist. With the assistance of illustrator Rockwell Kent, Ahgupuk became a member of the American Artist Group, exhibiting with them in 1937. His work was often emulated and, at times, copied outright. Ahgupuk's drawings are based on personal experiences and familiar scenes that he referred to as "Bering Sea pictures": hunting, fishing, villages, dog teams, and the blanket toss.

At about the time the market for Traditional Indian painting was beginning to wane, a move away from the "Traditional" dogma began to surface. The artists defined the change as a move toward a truer Indian perspective of fine art. New Indian Painting was not embraced by the "experts," who included collectors of Traditional Indian painting and institutions that promoted this painting. The period marked a turning point in the history of the Native Fine Art Movement. The artists and their work changed the course of that Movement. And, by doing so, cleared the way for future generations of Native artists.

OSCAR HOWE
(Yanktonai Sioux) b.1915-d.1983

Born: Joe Creek, Crow Creek Reservation, South Dakota
Education: The Studio, Santa Fe Indian School, New Mexico; B.A., Dakota Wesleyan University, Mitchell, South Dakota; M.F.A., University of Oklahoma, Norman

"Indian Art can compete with any Art in the world, but not as a suppressed Art."
O. Howe, 1958[15]

"Ghost Dance," 1960 [HM.IAC85]
watercolor on paper, 45.7x60.9 cm.
(color plate 41)

"So I had to concede that if Indian art were to exist I must do it as an individual effort. Indian art became an individualistic art. Versions of the old forms was not an obstacle but an evolvement in art. To find direction and to find some means of continuing my own work without losing individuality in work was quite a struggle at first."
O. Howe, Summer, 1969[16]

"Dance Of The Tree Dwellers," n.d. [MNM.1339.23P]
casein on paper, 43.5x58.5 cm. (fig.44)

In the late 1950s, Howe's style began to mature as he developed an abstract approach to his subject matter. This move toward the non-literal was criticized by Indian art "experts." Howe did not listen to the criticism and changed the course of Indian art forever.

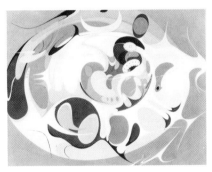

"Indian In Nature," 1970 [HM.IAC366]
gouache on paper, 48.2x60.9 cm. (fig.43)

"What I hope to accomplish in my painting is satisfaction in content and form with completeness and clarity of expression, and to objectify the "truths" in Dakota culture and present them in an artistic way."
O. Howe, Summer, 1969[17]

"Elk Game," 1948 [IACB]
casein on paper, 47x55.5 cm. (fig.45)

In 1935, Howe became a student of Dorothy Dunn at the now-famous Studio in Santa Fe, and, while there, received much recognition for his art. Howe's early paintings, with their boldly outlined, monumental figures and flat areas of color, reflect the influences of The Studio.

JOE HERRERA
(Cochiti) b.1923

Born: Cochiti Pueblo, New Mexico
Education: The Studio, Santa Fe Indian
School, New Mexico; B.A. and M.A., Uni-
versity of New Mexico, Albuquerque; stud-
ied with Raymond Jonson

"*Springtime Ceremony for Owah*," 1983
[HM.IAC2372]
watercolor on paper, 73.7x94 cm.
(color plate 42)

Herrera's combination of the dancer motifs
with the non-objective spattering technique
brings a freshness and new vitality to this
commonly portrayed image.

"*Comanche Dance*," c.1940
[SAR.1985.20.99.V1.P55]
watercolor on paper, 33.8x34.5 cm. (fig.46)

Herrera learned his early style of Tradi-
tional Southwest painting from his famous
mother, Tonita Peña. This line of dancers
displays Herrera's early style, with its detail
of dancers' clothing and mannerisms.

"*Petroglyph (Altar) Figures*," c.1952-56
[CAL.ACAD.370-1147]
casein on paper, 56.5x43 cm. (fig.47)

Herrera began to move away from the South-
west style of painting as he started to ex-
plore the traditional kiva murals and cave
drawings. He reproduced the images onto
paper, perfecting his non-objective, spatter-
ing technique. These abstract, highly sym-
bolic paintings challenged the validity of the
Southwest style and influenced a genera-
tion of artists.

PATRICK DesJARLAIT
(Chippewa) b.1921-d.1973

Born: Red Lake, Minnesota
Education: Pipestone Indian Training
School, Pipestone, Minnesota; Phoenix Jun-
ior College, Arizona

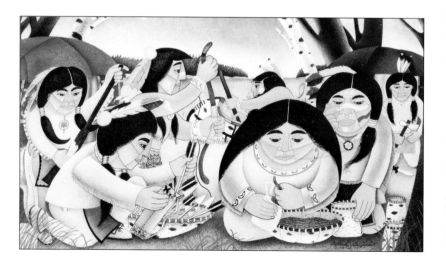

"*Gathering Wild Rice*," c.1971
[Private Collection]
watercolor on paper, 27.8x39.5 cm.
(color plate 43)

DesJarlait's paintings, reminiscent of the
Mexican muralists, are unique to Native
fine art. His monumental figures stoically
work at common tasks. DesJarlait fills the
entire picture plane with jeweled colors and
fine brush work. His work signaled change,
as the incorporation of Modern art styles
became more apparent in the Native Ameri-
can Fine Art Movement.

"*Chippewa Preparing For War*," c.1971
[Private Collection]
watercolor on paper, 55x90.5 cm. (fig.48)

Aspects of Cubism can be seen in DesJar-
lait's work, along with influences of the
Mexican muralists. His approach is softer
and rounder than that of the Cubist Move-
ment.

GEORGE MORRISON
(Ojibway) b.1919

Born: Grand Marais, Minnesota
Education: Minneapolis School of Art,
Minnesota; University of Aix-en-Marseille,
Aix-en-Provence, France; The Art Student
League, New York, New York

"The White Painting," 1971 [HM.IAC452]
acrylic on canvas, 115x152.5 cm.
(color plate 44)

Morrison's experimentation with art media
set him apart from Indian artists of his
generation. This painting uses the optical
illusion of Pointalism to create the appear-
ance of an all white surface.

"Path Rising to the Night," 1977 [UM.85.35]
collage, paper on canvas board,
50.8x30.4 cm. (fig.49)

Morrison was the first Native artist to be
appointed to the faculty of a major art
school, the Rhode Island School of Design.
In 1970, he left this tenured position to
return to his home state of Minnesota
where he assumed a temporary position in
the art department of the University of
Minnesota, Minneapolis, and helped start
the Indian Studies Program.

"New York," 1961 [Artist's Collection]
India Ink on paper, 43.1x35.5 cm. (fig.50)

Morrison was the first and most prominent
Indian artist on the New York art scene. He
considered himself to be an Indian who is
an artist, rather than an Indian artist.

In 1959, a conference, sponsored by the Rockefeller Foundation, was held at the University of Arizona to discuss the status of Indian art. The Southwest Indian Art Project was established as a result of the conference. The project consisted of summer programs (1960-1961) that featured special art instruction in both traditional tribal arts and contemporary, mainstream fine art. The aim of the project was to "develop an individual creative consciousness, and to develop to the fullest his talent in art without the loss of pride in himself as an Indian."[18] The project's success led to the establishment of the Institute of American Indian Art (IAIA), Santa Fe, New Mexico, in 1962. IAIA has produced a generation of young Native artists that has defined contemporary Indian art and has made its mark in history.

HELEN HARDIN
(Santa Clara) b. 1943-d. 1984

Born: Albuquerque, New Mexico
Education: Southwest Indian Art Project, University of Arizona, Tucson

"Recurrence of Spiritual Elements," 1973 [HM.IAC461]
acrylic on masonite, 83.8x66 cm.
(color plate 45)

Hardin's own style was influenced by Joe Herrera, her teacher at the Southwest Indian Art Project, and by her mother, Pablita Velarde. Hardin became one of the best-known women Native artists of her generation. Hardin's stylized design elements are complicated, yet executed with sharp clean lines having a draftsman-like quality.

MICHAEL KABOTIE
(Hopi) b. 1942

Born: Shungopavi, Second Mesa, Arizona
Education: Southwest Indian Art Project, University of Arizona, Tucson

"Petrogylphs," 1967 [HM.IAC40]
casein on paper, 38.1x50.8 cm.
(color plate 46)

Kabotie's influences include his father, painter Fred Kabotie, as well as, Joe Herrera, who was his instructor at the Southwest Indian Art Project. Although influenced by these artists, Kabotie has developed an abstract style based on Hopi symbols and designs. In 1973, he co-founded The Artist Hopid, a group of contemporary Hopi artists. Their work uses traditional Hopi images that are approached with experimental techniques and innovative ideas.

MARY MOREZ
(Navajo) b. 1938

Born: Tuba City, Arizona
Education: Southwest Indian Art Project, University of Arizona, Tucson

"Study Of A Navajo Woman," 1969 [HM.IAC904]
Conté crayon on paper, 63.5x53.3 cm.
(color plate 47)

Morez has developed a personal style that blends Cubism, Abstract Expressionism, and the symbolic abstraction of Joe Herrera. This study was made during an art demonstration at The Heard Museum. The work is characterized by grace of line work and gentle, realistic rendering of the human form.

FRITZ SCHOLDER

(Luiseño) b.1937

Born: Breckenridge, Minnesota
Education: B.F.A., California State University, Sacramento; M.F.A., University of Arizona, Tucson; Southwest Indian Art Project, Tucson

"Indian Wrapped In Flag," c. 1976
[Private Collection]
acrylic on canvas, 172.5x137 cm.
(color plate 48)

Scholder became an instructor at the newly established Institute of American Indian Art (IAIA) in 1962, at a time when the institution was enjoying a remarkable amount of talent, commitment, and economic support. It was during this period that Scholder completed his most famous series of paintings, the *Indian Series.* In the series, Scholder combined the Abstract Expressionism of Francis Bacon with the Pop Art of Wayne Thiebaud and the influences of his students, such as Bill Soza and T.C. Cannon.

T.C. CANNON

(Caddo/Kiowa) b.1946-d.1978

Born: Lawton, Oklahoma
Education: Institute of American Indian Art, Santa Fe, New Mexico; College of Santa Fe, New Mexico; Art Institute of San Francisco, California; Central State University, Edmond, Oklahoma

"Osage with Van Gogh" or *"Collector #5,"*
c.1980 [HM.IAC1953]
woodcut after a painting by the same title
(25/200), 64x51 cm.
(color plate 49)

This printed image has been referred to as a self-portrait by Cannon "done with a wit and richness of invention that echoes the metaphysical poetry of John Donne."[19]

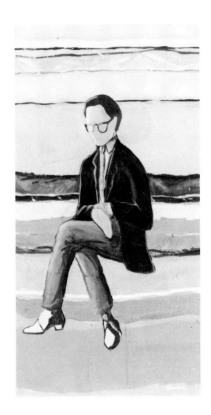

"Instructor in Green," c.1967 [IAIA.]
acrylic and oil on canvas, 183x96 cm. (fig.51)

This portrait of Scholder was done as a class assignment at IAIA. Cannon studied with Fritz Scholder at IAIA and exhibited with him in a two-person show at the National Museum of American Art. Their work has often been compared.

R.C. GORMAN

(Navajo) b.1932

Born: Chinle, Arizona
Education: Guam Territorial College, Marianas Islands; California State University, San Francisco; Arizona State College, Tempe; Mexico City College, Mexico City, D. F., Mexico.

"Navajo Woman," 1973 [HM.IAC503]
watercolor on paper, 73x58.5 cm.
(color plate 50)

Gorman is the most commercially successful and publicly popular Indian artist of all time. Native women are his main subjects. They are earthy, stoic, mysterious, and invitingly distant. Gorman draws these women in a simple manner, using an economy of line influenced by his time spent in Mexico.

The following artists are recognized as leaders in the contemporary Native American Fine Art Movement. Stylistically, philosophically, and culturally, they are a diverse group. They confirm the vitality of Native American fine art and guarantee its future.

LINDA LOMAHAFTEWA
(Hopi/Choctaw) b.1947

Born: Phoenix, Arizona
Education: Institute of American Indian Art, Santa Fe, New Mexico; B.F.A. and M.F.A., San Francisco Art Institute, California

"I use designs and colors to represent my expressions of being Indian."
L. Lomahaftewa[20]

"New Mexico Sunset," 1978 [HM.IAC2390]
acrylic on canvas, 130x104 cm.
(color plate 51)

This painting, the last in a series of abstract landscapes, was the first canvas Lomahaftewa did upon moving to New Mexico in 1978. The complex overlaying of designs and colors are reminiscent of patchwork quilts. This series is representative of Lomahaftewa's most powerful, early work.

GEORGE LONGFISH
(Seneca/Tuscarora) b.1942

Born: Oshweken, Ontario, Canada
Education: B.F.A. and M.F.A., The Art Institute of Chicago, Illinois

"It was this spirituality that made connections between making art and my cultural background...my style began to emerge in 1976 and I watched with amazement..."
G. Longfish. 1983[21]

"Spirit Guide/Spirit Healer," 1983 [HM.IAC2218]
acrylic on paper, 101.6x76.2 cm.
(color plate 52)

"I don't like to make a statement about my art that rigidly codifies it. I feel that it is important that the observer bring his or her own sensibilities to the work and make an interpretation based on an individual act of looking."
G. Longfish, 1985[22]

JAUNE QUICK-TO-SEE SMITH
(Cree/Flathead/Shoshone) b. 1940

Born: St. Ignatius, Flathead Indian Reservation, Montana
Education: B.A., Framingham State College, Massachusetts; M.F.A., University of New Mexico, Albuquerque

"By itself this work isn't going to make change, but I hope it can move people–some people–to think about these issues. Maybe it can make people see things in a little different way–so the message stays, if only for a moment."
J. Quick-To-See Smith, August 26, 1990[23]

"Rain," 1990 [HM.IAC2477]
mixed-media, A:203x76 cm. B:29.1x29.2 cm. C:30x30.5 cm.
(color plate 53)

An outspoken advocate for Native issues, Smith's latest works, *Chief Seattle Series*, is concerned with universal issues of the environment.

HARRY FONSECA

(Maidu/Portuguese/Hawaiian) b.1946

Born: Sacramento, California
Education: California State University, Sacramento

"I believe my Coyote paintings to be the most contemporary statements I have painted in regard to traditional beliefs and contemporary reality. I have taken a universal Indian image, Coyote, and have placed him in a contemporary setting."
H. Fonseca[24]

"When Coyote Leaves The Reservation (a portrait of the artist as a young Coyote)," 1980 [HM.IAC1412]
acrylic on canvas, 122x91.5 cm.
(color plate 54)

Coyote has been Fonseca's most popular and influential image. Stylistically, Fonseca works with flat areas of color and two-dimensional forms, influenced by Fauvism, Primitivism, Pop Art, and Traditional Indian Painting.

JAMES LAVADOUR

(Walla Walla) b. 1951

Born: Cayuse, Oregon
Education: No formal art training

"All I am doing is creating mass until the painting begins to speak, to say something I recognize. The act of painting is an event of nature."
J. Lavadour, 1990[25]

"New Blood," 1990 [Artist's Collection]
oil on linen, 46x234 cm.
(color plate 55)

Lavadour's multi-canvas paintings are illusionistic landscapes. The thinly applied paint allows for other-worldly images to emerge and become a part of the conscious world.

KAY WALKINGSTICK

(Cherokee) b.1935

Born: Syracuse, New York
Education: B.F.A., Beaver College, Glenside, Pennsylvania; M.F.A., Pratt Institute, Brooklyn, New York

"I am interested in the interrelationship between ideas and empirical reality. It is important that in the diptychs, the two portions speak to one another, while there remains some mystery in their relationship. They are not either/or. One is not the abstraction of the other."
K. WalkingStick, 1987[26]

"Uncontrolled Destiny," 1989
[Artist's Collection]
acrylic, oil, and wax on canvas diptych, 91.5x183 cm.
(color plate 56)

WalkingStick's interest in dualities is explored in her choice of the diptych format. Her canvases are companion panels, not separate units. Each is necessary to complete the whole. The abstract panel is richly layered with paint that has been manipulated and build up in an impasto manner, then cut away to expose the bottom layers. The other panel is resisted as the thick paint reveals a waterfall, beckoning the viewer into the picture plane.

The contemporary Native American sculpture tradition is relatively new, with the artistic style of Allan Houser dominating its fifty-year history. Other individuals have also contributed to the movement: some lesser known and some just beginning to make their mark. Although in its infancy, if the talents of the following artists are any clue, it has a very bright future.

WILLARD STONE
(Cherokee) b.1916-d.1985

Born: near Oktaha, Oklahoma
Education: Bacone Junior College, Bacone, Oklahoma

"Wood is a perfect medium, there are so many different colors and grains. Wood has a warmth that nothing else has."
W. Stone, 1977[27]

"Young Rabbit Hawk," 1968 [HM.IAC2338]
wood, 45.7x12.7x10.2 cm.
(color plate 57)

Stone has been a major force in Indian sculpture since 1940. He has perfected a smooth, rounded, wood sculpting style that has come to be recognized as a regional style unique to Oklahoma.

W. RICHARD WEST
(Cheyenne) b. 1912

Born: near Darlington, Oklahoma
Education: Bacone Junior College, Bacone, Oklahoma; B.A. and M.F.A., University of Oklahoma, Norman; University of Tulsa, Oklahoma; University of Redlands, California; mural instructions under Olaf Nordmark, Phoenix, Arizona

"Cheyenne Wolf Warrior," 1970
[HM.IAC2337]
wood, 55.8x20.3x12.7 cm. (fig.52)

West continues the Oklahoma sculpture style established by Willard Stone. The curvilinear lines are enhanced by the warm wood tones.

JOHN JULIUS WILNOTY
(Cherokee) b.1940

Born: Bigwitch, North Carolina
Education: No formal art training

"I carve because that is the talent God gave me, and I was lucky I found it."
J. Wilnoty[28]

"Up From The Deep," 1971
[IACB.W71.38.1]
catlinite, 34.5x34x17 cm.
(color plate 58)

Wilnoty brings the folk history of the Eastern Cherokee people to life. His pipestone carvings are meticulously detailed. His study of pre-Columbian pipe bowls of the southeastern United States influenced his multi-figure carvings.

DUFFY WILSON
(Tuscarora/Iroquois) b.1925

Born: Lewiston, New York
Education: No formal art training

"*ToDoDaHo,*" 1973 [HM.IAC418]
stone, 17x24x29 cm.
(color plate 59)

Wilson, a former construction painter, has been credited with revitalizing the carving and sculpting traditions of his people, the Iroquois. His contemporary sculptures depict their history.

JOHN HOOVER
(Aleut) b.1919

Born: Cordova, Alaska
Education: Leon Derbyshire School of the Fine Arts, Seattle, Washington; artist-in-residence, Institute of American Indian Art, Santa Fe, New Mexico

"*Shaman In Form Of An Eagle,*" 1973 [HM.IAC532]
polychrome wood, 223x100x20 cm.
(color plate 60)

Hoover describes his work as "shamanistic" because it symbolizes man's fear of the unknown. His hinged contemporary carvings are reminiscent of traditional transformation masks. The surfaces of his sculptures show the unmistakable marks of traditional tools.

ALLAN HOUSER
(Chiricahua Apache) b.1915

Born: Apache, Oklahoma
Education: Haskell Indian College, Lawrence, Kansas; The Studio, Santa Fe Indian School, New Mexico; mural instruction under Olaf Nordmark at Fort Sill, Oklahoma

"*Sheltered,*" 1979 [HM.IAC2342]
bronze, 38.1x15.2x10.2 cm.
(color plate 61)

Houser's style has been influenced by the Mexican muralists and British artist Henry Moore, who in turn had been influenced by pre-Columbian Chacmool figures from Mexico. Houser cast his first bronze at Nambé in Pojoaque, New Mexico, in 1968.

"*Eagle With Fish,*" 1973 [HM.IAC537]
alabaster, 41x41x25.5 cm. (fig.53)

Houser has been referred to as the "Grandfather of Contemporary Native American Sculpture." He began sculpting in 1940, at the height of his painting career. He first experimented with wood carving, later working in stone and bronze.

"*Coming Of Age,*" 1977 [DAM, Gift of Mr. and Mrs. Sidney Mozer and Family]
bronze, 20.3x40.6x17.8 cm. (fig.54)

This memorial bronze was commissioned by the Denver Art Museum in 1977.

GEORGE MORRISON
(Ojibway) b.1923

Born: Chippewa City, Minnesota
Education: Minneapolis School of Art,
Minnesota; Student Art League, New York,
New York

*"In this search for my own reality I seek the
power of the rock, the magic of the water, the
religion of the tree, the color of the wind and
the enigma of the horizon."*
G. Morrison, 1987[29]

*"Northwest Area Foundation
Commemorative Totem,"* 1982
[Artist's Collection]
bronze, 27.9x10.2x10.2 cm. (fig.55)

The strength and power of Morrison's large
totems is conveyed in this piece.

"Chiringa Form, Small #1," 1987
[Artist's Collection]
purple heart and padouk wood,
25.5x20x10 cm.
(color plate 62)

Morrison's understanding of the warmth
and beauty of wood and other natural mate-
rials is demonstrated in this piece.

BOB HAOZOUS
(Apache/Navajo/English/Spanish) b.1943

Born: Los Angeles, California
Education: Utah State University, Logan;
California College of Arts and Crafts,
Oakland

*"I try to deal honestly and directly with reality
in my art and that reality encompasses both
ugliness and beauty. I love the land and I love
people and I hope that my work symbolizes
this in my own individual way."*
B. Haozous, 1983[30]

"Apache Pull Toy," 1989 [HMD.]
cut and painted steel, 137.2x121.9x40.6 cm.
(fig.56)

Irony, bordering on the sarcastic, is at the
basis of this thought-provoking piece.
Haozous is one of the few sculptors who
have broken away from the Houser-esque
style of Indian sculpture. Ironically, he is
Houser's son.

"Ozone Madonna," 1989 [HM.IAC2378]
painted mahogany and steel,
145x52.5x30 cm.
(color plate 63)

Social commentary is an integral part of
Haozous' work. A recurring theme is the
threat of destruction that white society has
imposed on Native cultures. "Ozone Ma-
donna" deals with the threatened destruc-
tion of the tropical rain forests of South
America.

"Woman In Love," 1983 [HM.IAC1919]
stainless steel, 116.8x134.6x20.3 cm. (fig.57)

Haozous's uncanny ability to understand
human nature is humorously depicted in
this steel work. The horizontal figure
"floats" in a daze, eyes closed, a smile on
her face–in love. The surface is etched with
buffalos, used by Haozous as a personal
iconographic design element and a direct
reference to the stereotypical, romanti-
cized past of the Indian.

LARRY BECK
(Yup'ik) b.1938

Born: Seattle, Washington
Education: B.F.A., Sculpture, and M.F.A.,
Painting, University of Washington,
Seattle

*"When I begin a piece of work, a sculpture or
a mask, I want this work to have a certain
magic or power....Finding and refining this
connection is the essence of my work."*
L. Beck, 1987 [31]

*"Poonka Timertik Inua (Punk Walrus
Spirit),"* 1987 [HM.IAC2207]
mixed-media, 47x28x31.5 cm.
 (color plate 64)

Beck's inspiration comes from the ancient
Yup'ik mask forms of his ancestors. As with
those ancient masks, an integral part of the
creative process is gathering the materials.
Beck's pieces are made from contempo-
rary "found" materials. Materials that once
had another "life" are recycled into a new
meaning.

TRUMAN LOWE
(Winnebago) b.1944

Born: Black River Falls, Wisconsin
Education: B.A., University of Wisconsin,
LaCrosse; M.F.A., University of Wisconsin,
Madison

*"I do not change existing shapes, but I ar-
range them differently, use them in new
combinations. I combine shapes in various
arrangements in order to discover and make
accessible to others the elegance, simplicity
and functions of important structures and
designs in Indian culture."*
T. Lowe[32]

"Mnemonic Totem #3," 1989 [HM.IAC2379]
bronze, 120x25x25 cm. (color plate 65)

Lowe's Winnebago culture is reflected in
his interest in natural forms. He uses natu-
ral materials in a modern context, recalling
his ancestors and his connection to them
through his art.

ROXANNE SWENTZELL
(Santa Clara) b.1962

Born: Taos, New Mexico
Education: Institute of American Indian
Art, Santa Fe, New Mexico; Lewis and
Clark College, Portland, Oregon

"The Emergence Of The Clowns," 1988
[HM.IAC2344]
coiled and scraped clay, A: 58.4x33x33 cm.
B: 43.2x55.9x45.7 cm. C: 43.2x35.6x35.6 cm.
D: 17.8x48.3x26 cm. (color plate 66)

Swentzell's sculptures are incredible stud-
ies of the human form and human nature.
Her coil-built figures capture gestures,
poses, and facial expressions that change
with each examination.

R.E. BARTOW
(Yurok) b. 1946

Born: Newport, Oregon
Education: B.A., Western Oregon State
College, Monmouth

*"The direction of the mask is a bit like water-
color painting–you can direct but not dictate
the outcome...There are also times when the
wood directs the cuts..."*
R. Bartow, 1989[33]

"Salmon Mask," 1987 [HM.IAC2386]
mixed-media, 45.7x30.5x20.3 cm.
(color plate 67) photo credit: Alfred Jacobs

The influences of traditional Northwest
Coast masks are immediately apparent.
This contemporary piece has even been
mistaken for a traditional mask. Rather, it
may be considered homage to the great
Northwest Coast masks.

The history of the Native American Fine Art Movement would be incomplete without acknowledging the impending 1992 Quincentenary Anniversary of Columbus and his voyages. Selected artists have produced works for this exhibition in keeping with the theme, "Encounter and Response." Some chose to address the subject of Columbus directly, while others have created more general expressions of "encounter and response."

RIC DANAY
(Mohawk) b.1942

Born: Coney Island, New York
Education: B.A., California State University, Northridge; M.F.A., University of California, Davis

"Coast To Coast and See To Sea," 1981 [Artist's Collection]
mixed-media, 25.3x38.2x7 cm.
(color plates 68 and 69)

"*Chief's Chair,*" 1987 [Artist's Collection]
mixed media, 50x39x34 cm. (fig.58)

JEAN LAMARR
(Pitt River/Paiute) b.1945

Born: Susanville, California
Education: Philco-Ford Technical Institute, Santa Clara, California; San Jose City College, California; University of California, Berkeley

"Double Vision," 1991 [Artist's Collection]
mixed-media installation, 5.05x5.05 m.
(figs. 59 and 60)

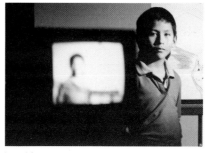

HARRY FONSECA
(Maidu/Portuguese/Hawaiian) b.1946

Born: Sacramento, California
Education: California State University, Sacramento

"Magic Box, #2," 1990 [Artist's Collection]
mixed-media, 90x163x65 cm.
(color plates 70 and 71)

BOB HAOZOUS

(Apache/Navajo/English/Spanish) b.1943

Born: Los Angeles, California
Education: Utah State University, Logan;
California College of Arts and Crafts,
Oakland

"The Abortionist's Bed," 1990
[Artist's Collection]
cut steel, 2.22x1.07x2.22 m.
(color plate 72)

HULLEAH TSINHNAHJINNIE

(Seminole/Creek/Navajo) b.1954

Born: Phoenix, Arizona
Education: Institute of American Indian
Art, Santa Fe, New Mexico; California College of Arts and Crafts, Oakland

*"When Did Dreams Of White Buffalo Turn To
Dreams Of White Women,"* 1990
[Artist's Collection]
photo collage, 63x25 cm.
(color plate 73)

JAMES LUNA

(Luiseño/Diegueño) b.1950

Born: Orange, California
Education: B.A., University of California,
Irvine; M.S., San Diego State University,
California

*"The Creation and Destruction of an Indian
Reservation,"* 1990 [Artist's Collection]
video and mixed-media installation,
6.1x2.4 m.
(color plate 74)

FRANK LAPENA

(Nomtipom Wintu) b.1937

Born: San Francisco, California
Education: B.A., California State College,
Chico; Life Issue, Teaching Credential, San
Francisco State University, California;
M.F.A., California State University, Sacramento

"Earth Mother (Red Cap)," 1990
[Artist's Collection]
acrylic on canvas, 121.5x91.5 cm.
(color plate 75)

G. PETER JEMISON
(Seneca) b.1945

Born: Silver Creek, New York
Education: B.S., State University College,
Buffalo, New York; University of Siena,
Siena, Italy; State University of New York,
Albany

"Buffalo Road III–Choice," 1990
[Artist's Collection]
mixed-media, 121.9 x 152.4 cm.
(color plate 76)

HM The Heard Museum, Phoenix, Arizona
GM The Gilcrease Museum, Tulsa, Oklahoma
OHS Oklahoma Historical Society, Oklahoma City, Oklahoma
NMAI National Museum of the American Indian, Smithsonian Institution,
 Washington, D.C.
SAR School of American Research, Santa Fe, New Mexico
MNM Museum of New Mexico, Santa Fe, New Mexico
IACB Indian Arts and Crafts Board, U.S. Department of the Interior, Washington, D.C.
CAL.ACAD. California Academy of Science, San Francisco, California
DAM Denver Art Museum, Denver, Colorado
OU.AM University of Oklahoma Museum of Art, Norman, Oklahoma
PAC Philbrook Art Center, Tulsa, Oklahoma
IAIA Institute of American Indian Art, Santa Fe, New Mexico
HMD Hood Museum, Dartmouth College, Dartmouth, New Hampshire
UM University Art Museum, University of Minnesota, Minneapolis

[1] Mole, "Painter of Pictures," July 8, 1951.
[2] Callander, *Shawnee Homelife: The Paintings of Ernest Spybuck*, 9.
[3] Polelonema to Leslie Van Ness Denman, IACB Record Group 435, box 13, National Archives, Washington, D.C. Personal correspondence.
[4] Rosenbrough, November 19, 1989.
[5] Carlson, June 8, 1984.
[6] Johnson, July 23, 1986.
[7] U. S. Department of the Interior, *Paintings by Blackbear Bosin*, Aug. 8 - Sept. 30, 1976, in Blackbear Bosin, Native American Artists Resource Collection, The Heard Museum, Phoenix.
[8] Hyatt, December 7, 1952.
[9] Highwater, *The Sweet Grass Lives On*, 98.
[10] Pitts, November 29, 1970.
[11] Snodgrass, *American Indian Painters: A Biographical Directory*, 166.
[12] Native American Center for the Living Arts, *American Indian Art in the 1980's*, 6.
[13] Day, Native American Artists Resource Collection, The Heard Museum, Phoenix.
[14] Yorba, *Drawn from the Surroundings: The Elkus Collection*, 6.
[15] Dockstader, ed. *Oscar Howe A Retropspective Exhibition*, 19. Letter from Howe to J. Snodgrass.
[16] Howe, "Theories and Beliefs–Dakota," *South Dakota Review* (Summer, 1969) 75.
[17] Ibid., 72.
[18] Patrick, et al., *Southwest Indian Art: Report to the Rockefeller Foundation*, 2.
[19] Wallo and Pickard, *T.C. Cannon, Native American: A New View of the West*, 112.
[20] Highwater, *The Sweet Grass Lives On*, 138.
[21] Longfish, Native American Artists Resource Collection, The Heard Museum, Phoenix.
[22] The College of Wooster Art Museum, *Four Native American Painters*.
[23] Clark, August 26, 1990.
[24] Highwater, *The Sweet Grass Lives On*, 74.
[25] Roberts, *Northwest Viewpoints: James Lavadour*.
[26] New Jersey State Council on the Arts, "On the Cover," *Arts New Jersey*, Fall, 1987, 18.
[27] U.S. Department of the Interior, Indian Arts and Crafts Board, *Sculpture by Willard Stone*. Washington, D.C: Indian Arts and Crafts Board, Dec. 5-Jan. 5, 1977. Exhibition Catalogue.
[28] Highwater, *The Sweetgrass Lives On*, 184.
[29] Minnesota Museum of Art, *Standing In the Northern Lights: George Morrison, A Retrospective, 1990*, 32.
[30] Haozous, Native American Artists Resource Collection, The Heard Museum, Phoenix.
[31] Portland Art Museum, *New Directions Northwest: Contemporary Native American Art*, 1987, 25.
[32] Lowe, Artist statement in Native American Artists Resource Collection, The Heard Museum, Phoenix.
[33] Archuleta, The Heard Museum, *The 4th Biennial Native American Fine Arts Invitational*, 1989.

Aberbach Fine Art. *T.C. Cannon Memorial Exhibit*. New York: Aberbach Fine Art, December 1979. Exhibition catalogue.

Aldmann, Jan E. "Bob Haozous." *Arts Magazine,* September 1981, 16.

Alexander, Hartley Burr. *Pueblo Indian Painting*. 1932. Reprint. Santa Fe N.Mex.: Bell Editions, 1979.

_____*Sioux Indian Paintings*. 2 vols. Nice, France: C. Szwedzicki, 1938.

Altbach, Philip S. and Gail P. Kelly, eds. *Education and Colonialism*. New York and London: Longman, Inc., 1978.

American Indian Contemporary Arts Gallery. *Portfolio II: Eleven American Indian Artists*. San Francisco: American Indian Contemporary Arts Gallery, 1988. Exhibition catalogue.

_____*Portfolio: Eleven American Indian Artists*. San Franciso: American Indian Contemporary Arts Gallery, 1986. Exhibition catalogue.

Amon Carter Museum of Western *Art. Institute of American Indian Art, Alumni Exhibition*. Dallas: Amon Carter Museum of Western Art, December 17, 1973-January 28, 1974. Exhibition catalogue.

Anthony, Kathryn. "Standing Tall: The Remarkable Achievements of Allan Houser and John Hoover." *Focus Santa Fe* (August-September 1989): 22.

Archuleta, Margaret L. "The 4th Biennial Native American Fine Arts Invitational at The Heard Museum." *American Indian Art Magazine* 15, no. 1 (Winter 1989).

_____*The 4th Biennial Native American Fine Arts Invitational*. Phoenix: The Heard Museum, October 21, 1989-June 4, 1990. Exhibition catalogue.

_____"Networking–From Sacramento to Seattle." *Native Peoples, The Journal of The Heard Museum*. (Spring 1988).

_____*The 3rd Biennial Native American Fine Arts Invitational*. Phoenix: The Heard Museum. October 10, 1987-February 27, 1988. Exhibition catalogue.

_____"Coyote: A Myth in the Making." *Terra* (The Natural History Museum of Los Angeles County) 25, no. 2 (November/December 1986): 13-20.

Bacone College. *Bacone College Centennial Touring Art Exhibit*. Muskogee, Okla.: Bacone College, 1980. Exhibition catalogue.

Bass, Althea. *The Arapaho Way: A Memoir of an Indian Boy*. New York: Clarkson N. Potter, 1966.

Bellskin, Adelynn D. *Two American Painters: Fritz Scholder and T.C. Cannon*. Washington, D.C.: Smithsonian Institution Press, 1972. Exhibition catalogue.

Benton, William. "T.C. Cannon: The Masked Dandy." *American Indian Art Magazine* 3, no. 4 (1977).

Berkhofer, Robert F. *The White Man's Indian: Images of the American Indian from Columbus to the Present*. New York: Alfred A. Knopf, 1978.

Berstein, Bruce. "Frank LaPena: The Art and the Artist." *News from Native California* (May/June 1989): 6-7.

Blue Eagle, Acee. *Echogee*. Dallas: Palmco Investment Corporation, 1972.

Blue Eagle, Acee., ed. *Oklahoma Indian Painting-Poetry*. Tulsa Okla.: Acorn Publishing Company, 1959.

"Bob Haozous." *Horizon* (April 1982): 50.

Bois, Yve-Alain. "Resisting Blackmail: The Task of Art History Now." *The Journal of Art* 4 (February 1991): 65.

Breunig, Robert and Michael Lamatuway'ma. "Hopi Scenes of Everyday Life." *Plateau* (Museum of Northern Arizona) 55, no. 1 (1983).

Broder, Patricia J. *American Indian Painting and Sculpture*. New York: Abbeville Press, 1981.

_____*Hopi Painting: The World of the Hopis*. New York: E.P. Dutton, 1978.

Brody, J.J. "The Creative Consumer: Survival, Revival and Invention in Southwest Indian Arts." In *Ethnic and Tourist Arts* edited by Nelson H.H. Graburn. Berkeley: University of California Press, 1976.

_____*Indian Painters & White Patrons*. Albuquerque: University of New Mexico Press, 1971.

Brophy, William A. and Sophie E. Aberle. *The Indian: America's Unfinished Business; Report of the Commission on the Rights, Liberties and Responsibilites of the American Indian*. Norman, Okla.: University of Oklahoma Press, 1966.

Brown, Bill. "Copper Thunderbird: An Ojibway Paints His People's Past." *Weekend Magazine, Toronto Star*, June 12, 1962.

Calcagno, Nicholas. *New Deal Murals in Oklahoma*. Oklahoma City: Oklahoma Humanities Committee, 1976.

Callander, Lee A. and Ruth Slivka. *Shawnee Homelife: The Paintings of Ernest Spybuck*. New York: Museum of the American Indian, Heye Foundation, 1984.

Cardinal, Roger. *Primitive Painters*. New York: St. Martin's Press, 1979.

Cardinal-Schubert, Joane and Carol Podedworny. *Joane Cardinal-Schubert: This is My History*. Thunder Bay, Ontario, Canada: Thunder Bay National Exhibition Centre and Centre for Indian Art, 1985. Exhibition catalogue.

Carey, Beth. "Native Art a Misunderstood Tradition." *The Silhouette* (MacMaster University) (1979).

Carlson, David. "Weekend Job has Made Painter Famous." *Gallup Daily Independent,* June 8, 1984.

Carpenter, Carol Henderson. "Morrisseau-The Artist as Trickster." *Artmagazine*, November/December 1979.

Carroll, Joy. "The Strange Success and Failure of Norval Morrisseau." *Artscanada*, November/December 1964.

Cesa, Margaret. "Pop Goes the Mural." *The New Mexican,* February 16, 1990, 18.

Chapman, Kenneth M. *Pueblo Indian Painters*, 2 vols. Nice, France: C. Szwedzicki, 1936.

Chase, Katherine. "Navajo Painting." *Plateau* (Museum of Northern Arizona) 54, no. 1 (1982).

Cinader, Bernard and Peter K. Lewin. *Contemporary Native Art of Canada–The Woodland Indians*. Toronto: Toronto Ontario Museum, September-December 1976. Exhibition catalogue.

Clark, William. "Art-Active Voice: Artist Taps into Politics, Environment" *Albuquerque Journal*, August 26, 1990, F2.

Coe, Kathryn. "Bob Haozous at Gallery 10, Scottsdale." *Artspace,* Summer 1983, 74.

Coen, Rena N. *The Red Man in Art*. Minneapolis: Lerner Publications, 1972.

The College of Wooster Art Museum. *Four Native American Painters*. Wooster, Ohio: The College of Wooster, January 13-March 3, 1985. Exhibition catalogue.

Courlander, Harold. *Hopi Voices: Recollections, Traditions, and Narratives of the Hopi Indians*. Albuquerque: University of New Mexico Press, 1982.

Crimp, Douglas. "Pictures." In *Art After Modernism: Rethinking Representation* edited by Brian Wallis. New York: The New Museum of Contemporary Art, 1984.

Culley, LouAnn Faris. "Helen Hardin: A Retrospective." *American Indian Art Magazine* 4, no. 3 (1977).

C. W. Post Art Gallery, Long Island University. *The Unconquered Spirit: American Indian Paintings and Objects from the Philbrook Art Center*. Greenvale, New York: C.W. Post Art Gallery, Long Island University, February-March 1978. Exhibition catalogue.

Daniel, Ann. "Norval Morrisseau: Myth and Reality." *The Challenge* (Montreal), December 11, 1966.

Dawdy, Doris O.,comp. *Annotated Bibliography of American Indian Painting*. Vol. 21, Pt. 2, Contributions from the Museum of the American Indian, Heye Foundation. New York: Museum of the American Indian, Heye Foundation, 1968.

Day, Frank. Native American Artists Resource Collection. The Heard Museum, Phoenix.

Day, John A. and Margaret Quintal. "Oscar Howe." *Southwest Art*, June 1984.

Deats, Suzanne. "Haozous: Facing the Contradictions." *Santa Fe Reporter. Artists of the Sun*, August 19, 1987, 15.

Deernose, Kitty Belle. *Native American Visual Arts in Montana*. Miles City, Mont.: Custer County Art Center, 1986. Exhibition catalogue.

DeMott, Barbara. *Beyond the Revival: Contemporary Northwest Native Art*. Vancouver, British Columbia, Canada: Charles H. Gallery, Emily Carr College of Art and Design, July, 1989. Exhibition catalogue.

Denman, Leslie Van Ness. *The Peyote Ritual, Visions and Descriptions of Monroe Tsa Toke*. San Francisco: Grabhorn Press, 1957.

Dewfey, Selwyn. "Birth of a Cree-Ojibway Style of Contemporary Art." In *One Century Later* edited by Ian A.L. Getty. Vancouver, British Columbia, Canada: University of British Columbia Press, n.d.

D'Harnoncourt, Rene. "Challenge and Promise: Modern Art and Modern Society." *Magazine of Art* 41, no. 7 (November 1948): 252.

Dockstader, Frederick J. "The Revolt of Trader Boy: Oscar Howe and Indian Art." *American Indian Art Magazine* no. 3 (Summer 1983): 42.

Dockstader, Frederick J., ed. *Oscar Howe A Retrospective Exhibition*. Tulsa: Thomas Gilcrease Museum Association, 1982. Exhibition catalogue.

_____ed., *Directions in Indian Art*. Tucson: University of Arizona Press, 1959.

Douglas, F. H. "The Spring Exhibit of Indian Art." *El Palacio* (Museum of New Mexico) 38:24, 25, 26 (1935): 129-132.

Douglas, Frederic H. and Rene d'Harnoncourt. *Indian Art of the United States*. New York: The Museum of Modern Art, 1941. Exhibition catalogue.

Duffek, Karen. *Beyond History*. Vancouver, British Columbia, Canada: Vancouver Art Museum, 1989. Exhibition catalogue.

Dunn, Dorothy. "A Documented Chronology of Modern Indian Painting of the Southwest." *Plateau* (Museum of Northern Arizona) 44 (1972).

_____*American Indian Painting of the Southwest and the Plains Areas*. Albuquerque: University of New Mexico Press, 1968.

_____*Paintings by American Indians. A Memorial Exhibition Selected from the Collection of the Late William and Leslie Van Ness Denman*. San Francisco: California Palace of the Legion of Honor, 1962. Exhibition catalogue.

_____"The Studio of Painting, Santa Fe Indian School." *El Palacio* (Museum of New Mexico) 67, no. 1 (1960).

_____"America's First Painters." *National Geographic Magazine*, March 1955, 349-78.

_____"Indian Art in the Schools." *Indians at Work* (U.S. Department of the Interior) 3, no. 1 (1953): 20-21.

_____"Art of Joe Herrera." *El Palacio* (Museum of New Mexico) 12 (December 1952): 367.

_____*Contemporary American Indian Painting*. Washington, D.C.: National Gallery of Art, 1948. Exhibition catalogue.

Durham, Jimmie and Jean Fisher. *We the People*. New York: Artists Space Gallery, 1987. Exhibition catalogue.

_____*NI'GO TLUHN A DOH K A (We Are Always Turning Around...On Purpose)*. Long Island, New York: Amelie A. Wallace Gallery, State University of New York, College at Old Westbury, Long Island, New York, April 8-May 8, 1986. Exhibition catalogue.

Durham, Linda. "R.C. Gorman." *Southwest Art*, June 1978.

Eber, Dorothy. *Pitseolak: Pictures Out of My Life*. Seattle: University of Washington Press, 1979.

Ewers, John C. "The Emergence of the Named Indian Artist in the American West." *American Indian Art Magazine* 6, no. 2 (Spring 1981): 52-61, 77.

"Exhibit by Indian Pupils." *El Palacio* (Museum of New Mexico) 6 (1919): 142-143.

Fawcett, David M. and Lee A. Callander. *Native American Painting: Selections from the Museum of the American Indian*. New York: Museum of the American Indian, Heye Foundation, 1982.

Feder, Norman. *American Indian Art*. New York: Harry N. Abrams, Inc., 1971.

_____*Two Hundred Years of North American Indian Art*. New York: Praeger and Whitney Museum of American Art, 1971.

_____*North American Indian Painting*. New York: Museum of Primitive Art, 1967.

_____*American Indian Art Before 1850*. Denver: Denver Art Museum, 1965.

_____*Art of the Eastern Plains Indians*. New York: Brooklyn Museum, 1964.

Feest, Christian F. *Native Arts of North American*. New York: Oxford University Press, 1980.

Fewkes, Jesse Walter. "Hopi Kachinas, Drawn by Native Artists." *Annual Report 21*. Washington, D.C.: United States Bureau of American Ethnology, 1903.

_____"Tusayan Kachinas." *Annual Report 15*. Washington, D.C.: United States Bureau of American Ethnology, 1897.

The Five Civilized Tribes Museum. *The Master Artists of the Five Civilized Tribes*. Muskogee, Okla.: The Five Civilized Tribes Museum, 1976. Exhibition catalogue.

Flint Institute of Arts. *Art of the Great Lakes Indians*. Flint, Mich.: Flint Institute of Arts, 1973. Exhibition catalogue.

Fontain, Dick. *Cherokee Artist Bert D. Seaborn*. Oklahoma City: Prairie Hawk Publications, 1979.

Forrest, James T. "Preface." *Acee Blue Eagle: Memorial Exposition*. Tulsa, Okla.: Thomas M. Gilcrease Museum, 1959. Exhibition catalogue.

Foster, Hal. "Postmodernism: A Preface." In *The Anti-Aesthetic: Essays on Postmodern Culture* edited idem. Port Townsend, Wash.: Bay Press, 1983.

Frank, Patrick. "Art Expresses Indian Dilemma." *The State Hornet*, October 3, 1974, 3.

Furst, Peter T. and Jill L. Furst. *North American Indian Art*. New York: Rizzoli, 1982.

Galante, Gary. "The Painter: The Sioux of the Great Plains." In *The Ancestors: Native Artisans of the Americas* edited by Anna C. Roosevelt and James G. E. Smith. New York: Museum of the American Indian, 1979.

Gardiner Art Gallery, Student Union, Oklahoma University. *Contemporary Native American Indian Art*. Stillwater, Okla.: Gardiner Art Gallery, Student Union, Oklahoma University, October 28, 1983. Exhibition catalogue.

Gibson, A. M. "Exaltation of Life: The Art of the Southern Plains." *Four Winds* (Winter 1980): 49-53, 90-91.

Gibson, Daniel. "Allan Houser, Sculptor. A Man With A Vision Soaring Aspirations and Energy." *Santa Fean Magazine*, June 1988, 16.

Gilmore, E.L. *The Tiger Legacy*. Tulsa, Okla.: E. L. Gilmore, 1968.

Gladysz, Thomas. "Coyote is Hip, Coyote's Cool." *The Montclarion*, November 3, 1987.

Golder, Nina. *The Hunt and the Harvest: Pueblo Paintings from the Museum of the American Indian*. Hamilton, N.Y.: Gallery Association of New York, 1985.

Goldwater, Robert. *Primitivism in Modern Art*. Revised Edition. New York: Random House, Vintage Books, 1967.

Gorman, R.C. *Chinle to Taos*. Taos, N.Mex.: Navajo Gallery in conjunction with the Millicent Rogers Museum, 1988. Exhibition catalogue.

_____*R.C. Gorman, The Drawings*. Flagstaff, Ariz.: Northland Press, 1982.

_____*R.C. Gorman, The Posters*. Flagstaff, Ariz.: Northland Press, 1980.

_____"R.C. Gorman." *Southwest Art*, May 1971.

Gray, Samuel L. *Tonita Peña*. Albuquerque: Avanyu Publishing, 1990.

Greenberg, Henry and Georgia Greenberg. *Carl Gorman's World*. Albuquerque: University of New Mexico Press, 1984.

Gregory, Jack and Rennard Strickland. *American Indian Spirit Tales*. Muskogee, Okla.: Indian Heritage Association, 1974.

_____*Choctaw Spirit Tales*. Muskogee, Okla.: Indian Heritage Association, 1972.

_____*Creek-Seminole Spirit Tales*. Muskogee, Okla.: Indian Heritage Association, 1971.

_____*Cherokee Spirit Tales*. Muskogee, Okla.: Indian Heritage Association, 1969.

Guilbaut, Serge. *How New York Stole the Idea of Modern Art*. Translated by Arthur Goldhammer. Chicago: University of Chicago Press, 1983.

Haberland, Wolfgang. *Donnervogel und Rabunal*. Hamburg: Hamburgisches Museum fur Volkenkunde, 1979.

Haozous, Robert. Native American Artists Resource Collection. The Heard Museum, Phoenix.

Harding, Anne D. and Patricia Bolling. *Bibliography of North American Indian Art*. Washington, D.C.: Department of the Interior, Indian Arts and Crafts Board, 1938.

Harvey, Byron, III. *Ritual in Pueblo Art: Hopi Life in Hopi Painting*. New York: Museum of the American Indian, Heye Foundation, 1970.

Heap-of-Birds, Edgar. *Sharp Rocks*. Buffalo, N.Y.: CEPA, 1986. Exhibition catalogue.

The Heard Museum. *Houser and Haozous: A Sculptural Retrospective*. Phoenix: The Heard Museum, September 10-May 1, 1984. Exhibition catalogue.

_____*Fred Harvey Fine Arts Collection*. Phoenix: The Heard Museum, 1976.

Hibben, Frank C. *Kiva Art of the Anasazi*. Las Vegas, N.Mex.: KC Publications, 1975.

Highwater, Jamake. "Tiger: Another Look." *Native Arts West,* March 1981, 14-15.

_____"Fritz Scholder: Profiles of Contemporary North American Indian Artists." *Native Arts West*, February 1981, 58.

_____*The Sweet Grass Lives On*. New York: Harper and Row, 1980.

_____"Noble Savages and Wild Indians." *New York Arts Journal* 17 (January 1980): 22-24.

_____*Song from the Earth: American Indian Painting*. Boston: New York Graphic Society, 1976.

Hill, Tom. *A Celebration of Contemporary Canadian Native Art*. Brantford, Ontario, Canada: Woodlands Indian Cultural Education Centre, 1987. Exhibition catalogue.

_____"Politics and Indian Art." *Magazine* (Ontario Association of Art Galleries), Summer/Fall 1979.

_____"Indian Art Is Art, Not an Anthropological Curiousity." Paper presented at the 45th Annual Couchiching Conference on the Arts in Canada: Today and Tomorrow, Toronto, Ontario, Canada, 1976.

_____"The Paradox of Norval Morrisseau- A Film Review." *Tawow* no. 4 (Winter 1974).

Houle, Robert. "A Firm Statement on the Demoralization of Indian People." *The Native Perspective* 3, no. 2 (1978).

Houlihan, Patrick T. "Imagery from the Plains: R. Lee White and Jaune Quick-To-See Smith." *The Heard Museum Newsletter.* (November/December 1979): 2-3.

Howe, Oscar. "Theories and Beliefs–Dakota." *South Dakota Review.* (Summer 1969): 69-79.

Hume, Christopher. "The New Age of Indian Art." *Mc Clean's*, January 22, 1979.

Hurst, Tricia. "Helen Hardin." *Southwest Art*, June 1986.

_____"Jaune Quick-To-See Smith." *Southwest Art*, April 1981, 82-91.

Huyssen, Andreas. *After the Great Divide, Modernism, Mass Culture, Postmodernism*. Bloomington Ind.: Indiana University Press, 1986.

Hyatt, Robert M. "Crusading Artist." *Tulsa Sun World Magazine*, December 7, 1952, 26.

Indian and Northern Affairs Canada. *Atlantic Region, Indian Art Juried Exhibition*. Halifax, Nova Scotia, Canada: Indian and Northern Affairs Canada, November 1986. Exhibition catalogue.

The Institute of American Indian Arts. *A Basic Statement of Purpose*. Santa Fe, N.Mex.: The Institute of American Indian Arts, 1962.

International Native American Council of Arts. *Spirit of the Earth*. Niagara Falls, N.Y.: International Native American Council of Arts, 1980. Exhibition catalogue.

Iverson, Katherine. "Civilization and Assimilation in the Colonialized Schooling of Native Americans." In *Education and Colonialism* edited by Philip G. Altbach and Gail P. Kelly. New York and London: Longman, Inc., 1978: 153.

Jacka, Lois Esary and Jerry Jacka. *Beyond Tradition: Contemporary Indian Art and Its Evolution*. Flagstaff, Ariz.: Northland Press, 1988.

Jacknis, Ira and Teri Straus. "Discovering Indian Art: What Took Us So Long?" *Chicago Magazine*, July 1977.

Jacobson, O.B. and Jeanne D. D'Ucel. *Indian Artists from Oklahoma*. Norman, Okla.: University of Oklahoma Press, 1964.

_____*Kiowa Indian Art*. Nice, France: C. Szwedzicki, 1929.

_____*American Indian Painters*. Nice, France: C. Szwedzicki, 1950.

Jauss, Hans-Robert. "Literary History as a Challenge to Literary Theory." In *New Literary History* . 2 (1970): 9.

Johnson, Caroline. "Dick West: New Visions of Indian Traditions." *Tulsa Tribune*, July 23, 1986.

Jones, Don. H. "Harry Fonseca, Artist." *Santa Fean Magazine*, August 1984, 55-57.

Jopling, Carol F. *Art and Aesthetics in Primitive Societies: A Critical Anthology*. New York: E.P. Dutton, 1971.

Kabotie, Fred. *Designs from the Ancient Mimbrenos, With a Hopi Interpretation*. San Francisco: Grabhorn Press, 1949.

Kabotie, Fred and Bill Belknap. *Fred Kabotie: Hopi Indian Artist*. Flagstaff, Ariz.: Northland Press, 1977.

Katz, Jane. *This Song Remembers: Self-Portraits of Native Americans in the Arts*. Boston: Houghton Mifflin, 1980.

Kelsey, Andrea J., ed. *I Am These People: Native American Art Exhibition*. Sacramento, Calif.: California State Arts Commission, 1975. Exhibition catalogue.

Kenagg, Suzanne G. "Bob Haozous." *American Indian Art Magazine* (Summer 1990): 67.

King, Jeanne Snodgrass. "In The Name Of Progress Is History Being Repeated?" *American Indian Art Magazine* (Spring 1985): 27.

_____"Fred Kabotie." *Southwest Art*, November 1984, 59-62.

_____"Dorothy Dunn and the Studio." *Southwest Art*, June 1983, 72-79.

Kostich, Dragos D. *George Morrison*. Minneapolis: Dillon Press, 1976.

Kubler, George. *The Shape of Time*. New Haven, Conn.: Yale University Press, 1975.

LaPena, Frank R. and Janice T. Driesbach, eds. *The Extension of Tradition: Contemporary Northern California Art in Cultural Perspective*. Saramento, Calif.: Crocker Art Museum, July 13-October 6, 1985. Exhibition catalogue.

Lawrence, D.H. *Studies in Classic American Literature*. Revised Edition. New York: Penguin, 1961.

Lazore, Melissa. "David General Exploring Avenues." *The Native Perspective* 3, no. 2 (1978).

Libhart, Myles. *The Dance in Contemporary American Indian Art*. New York: Harkness House for Ballet Arts with the Indian Arts and Crafts Board, 1967.

Lieu, Jocelyn and Weisberg, Louis. "Traditional Indian Art A Misnomer." *Indian Market Journal North* (August 15, 1989).

Linker, Kate. "Representation and Sexuality." In *Art After Modernism: Rethinking Representation* edited by Brian Wallis. New York: The New Museum of Contemporary Art, 1984.

Lippard, Lucy R. "Native Intelligence." *The Village Voice*, December 27, 1983, 102.

Longfish, George. Artist Statement. Native American Artists Resource Collection. The Heard Museum, Phoenix.

Longfish, George and Joan Randall. "New Ways of Old Vision." *Artspace* 6 (Summer 1982): 25.

Lowe, Truman. Native American Artists Resource Collection. The Heard Museum, Phoenix.

Lucas, Phil. "Images of Indians." *Four Winds* (Autumn 1980).

Mainprize, Garry. *Stardusters: New Works by Jane Ash Poitras, Pierre Sioui, Joane Cardinal-Schubert, & Edward Poitras*. Thunder Bay, Ontario, Canada: Thunder Bay National Exhibition Centre and Centre for Indian Art, 1986. Exhibition catalogue.

Marriott, Alice. *Kiowa Years: A Study in Cultural Impact*. New York: Macmillan, 1968.

_____*The Ten Grandmothers*. Norman, Okla.: University of Oklahoma Press, 1945.

Maytag, Tim. "The Medium Dictates A Design By Haozous." *The New Mexican*, May 26, 1985, 123.

McCall, Celeste. "Shoshone Artist Adds Depth to Lithographs." *The Indian Trader*, August 1981, 35.

McConnell, Gordon. "Jaune Quick-To-See Smith: Speaking Two Languages." *The Catalogue of the Yellowstone Art Center*. Billings, Mont.: Yellowstone Art Center, September 7-October 26, 1986. Exhibition catalogue.

McGarry, Susan Hallsten. "Oscar Howe." *Southwest Art,* June 1982, 123-125.

McLuhan, Elizabeth. *WAABANADA-IWEWIN (WAH-BAHN-DAY-WIN): Northwestern Ontario Juried Indian Art Show*. Thunder Bay, Ontario, Canada: Thunder Bay National Exhibition Centre and Centre for Indian Art, 1984. Exhibition catalogue.

_____*Last Camp, First Song: Indian Art from the Royal Ontario Museum*. Thunder Bay, Ontario, Canada: Thunder Bay National Exhibition Centre and Centre for Indian Art, 1983. Exhibition catalogue.

_____*Norval Morrisseau: Recent Work*. Thunder Bay, Ontario, Canada: Thunder Bay National Exhibition Centre and Centre for Indian Art, 1983. Exhibition catalogue.

_____*Renewal: Masterworks of Contemporary Indian Art from the National Museum of Man*. Thunder Bay, Ontario, Canada: Thunder Bay National Exhibition Centre and Centre for Indian Art, 1982. Exhibition catalogue.

_____*The Secularization of Ojibway Imagery and the Emergence of Image Makers*: Contemporary Native Arts of Canada–Manitoulin Island. Toronto, Ontario, Canada: Royal Museum of Ontario, 1978. Exhibition catalogue.

The Mendal Art Gallery. *Edward Poitras: Indian Territory*. Saskatoon, Saskatchewan, Canada: The Mendal Art Gallery, June 10-July 24, 1988. Exhibition catalogue.

Metropolitan Museum of Art. *Masterworks from the Museum of the American Indian*. New York: Museum of the American Indian, Heye Foundation, 1973.

Milton, John R. *Oscar Howe*. Minneapolis: Dillon Press, 1976.

_____*The American Indian Speaks*. Vermillion, S.Dak.: University of South Dakota Press, 1969.

Minnesota Museum of Art. *Standing in the Northern Lights: George Morrison, A Retrospective*. Minneapolis: Minnesota Museum of Art, 1990. Exhibition catalogue.

Mole, Wayne D. "Painter of Pictures." Unknown Oklahoma newspaper, July 8, 1951, 9.

Momaday, Scott. *Names: A Memoir*. New York: Harper & Row, 1976.

Monthan, Doris. *R.C. Gorman, The Lithographs*. Flagstaff, Ariz.: Northland Press, 1978.

Monthan, Guy and Doris Monthan. *Art and Indian Individualists*. Flagstaff, Ariz.: Northland Press, 1975.

_____"Ha-So-De: One of the First Individualists." *American Indian Art Magazine* 1, no. 3 (1975): 34-39.

Mooney, James. *Calendar History of the Kiowa Indians*. Reissued with a new introduction by John C. Ewers. Washington, D.C.: Smithsonian Institution Press, 1979.

Moss, Lynde Bourque. *Montana Collects Montana*. Billings, Mont.: Montana Art Gallery, 1987. Exhibition catalogue.

National Gallery of Art. *Contemporary American Indian Painting*. Washington, D.C.: Smithsonian Institution, 1953.

Native American Center for the Living Arts. *American Indian Art in the 1980's*. Niagara Falls, N.Y.: Native American Center for the Living Arts, 1981.

Native Indian/Inuit Photographer's Association. *Niipa, Portrayals: Photography by Native Indian/Inuit People*. Hamilton, Ontario, Canada: Native Indian/Unuit Photographer's Association, 1987.

Nelson, Mary Carroll. *Allan Houser: Grand Master Apache Sculptor*. American Artist 44 (November 1980).

_____"Pablita Velarde." *American Indian Art Magazine* 3, no. 2 (Spring 1978): 50.

_____*Michael Naranjo: The Story of an American Indian*. Minneapolis: Dillon Press, 1975.

_____*Future Directions in Native American Art*. Santa Fe, N.Mex.: Institute of American Indian Art, 1972.

New, Lloyd Kiva. "Cultural Difference as the Basis for Creative Education." *Native American Arts,* 1 (1968):8.

New Jersey State Council on the Arts. "On the Cover." *Arts New Jersey* 2, no. 3 (Fall 1987): 18.

Newton, Douglas. *Masterpieces of Primitive Art*. New York: Alfred A. Knopf, 1978.

Nieto, John and Jay Scott. *John Nieto*. Tokyo: Axis Incorporated, 1989.

NI-WO-DI-HI Gallery. *Champion Javelin Portfolio*. Austin, Tex.: Champion Javelin, 1981.

Norman MacKensie Art Gallery. *Two Worlds: Contemporary Canadian Art from the Collections of Indian and Northern Affairs Canada*. Regina, Saskatchenwan, Canada: University of Regina, August 2-September 25, 1985. Exhibition catalogue.

"Norval Morrisseau." *Artscanada*, January/February 1963.

Oxendine, Lloyd E. "23 Contemporary Indian Artists." *Art in America*, July/August 1972, 58.

Parks, Stephen. *R.C. Gorman, A Portrait*. Boston: Little, Brown and Co., 1983.

_____ "Adopting, Adapting, and Rejecting: New Art of the American Indian." *Southwest Art*, April 1980.

Parry, Ellwood. *The Image of the Indian and the Black Man in American Art, 1590 - 1900*. New York: George Braziller, 1974.

Parson, James. *The Art Fever: Passages Through the Western Art Trade*. Taos N. Mex.: Gallery West, Inc., 1981.

Parsons, Elsie Clews. *Isleta Paintings*. Washington, D.C.: Smithsonian Institution, 1962.

Patrick, David L., Emil W. Haury, Sidney W. Little, Andreas Andersen, Clara Lee Tanner, and Robert Church. *Southwest Indian Art: Report to The Rockefeller Foundation*. Tucson: University of Arizona, 1960.

Peña, Amado Maurillio, Jr. and Howard L. Anderson. *Amado Maurillio Peña, Jr.* Albuquerque: Robert Stephan Young Publishing Company, 1981.

Perlman, Barbara H. *Allan Houser (HA-O-ZOUS)*. Boston: David R. Godine, 1987.

_____ "Allan Houser: Songs From The Earth." *Southwest Art*, June 1981, 48-58.

Peters, Susan. "Introduction," *The Peyote Ritual: Visions and Descriptions of Monroe Tsa Toke*. San Francisco: Grabhorn Press, 1957.

Philbrook Art Center. *Native American Art at Philbrook*. Tulsa, Okla.: Philbrook Art Center, 1980. Exhibition catalogue.

_____ *American Indian Paintings from the Collections of the Philbrook Arts Center*. Tulsa, Okla.: Philbrook Art Center, 1970. Exhibition catalogue.

_____ *American Indian Painting Exhibitions 1946-1980*. Tulsa, Okla.: Philbrook Art Center, n.d. Exhibition catalogue.

Phillip, Kenneth R., ed. *Indian Self-Rule: First Hand Accounts of Indian White Relations from Roosevelt to Reagan*. Chicago and Salt Lake City: Howe Brothers, 1986.

Phillips Academy. *Paintings and Pottery by Students of the Santa Fe School*. Andover, Mass.: Addison Gallery of American Art, 1934.

Phillips, Ruth. *Contemporary Indian and Inuit Art of Canada*. New York: United Nations General Assembly, November 1, 1983. Exhibition catalogue.

Pitts, Robbie. "Art is Tool in Crusade: Indian Hopes to Bridge Racial Gulf." Unknown Oklahoma newspaper, n.d.

Polelonema, Otis. Letter to Leslie Van Ness Denman. IACB Record Grp 435 Box 13. National Archives, Washington, D.C.

Pollock, Jack and Sinclair Lister. *The Art of Norval Morrisseau*. Toronto, Ontario, Canada: Methuen Publications, 1979.

Portland Art Museum. *New Directions Northwest: Contemporary Native American Art*. Portland: Oregon Art Institute, 1986.

Qoyawayma, Polingaysi. *No Turning Back*. Albuquerque: The University of New Mexico Press, 1964.

Ramsey, Laura. "General's Exhibition Title Appropriate." *The Brantford Expositor*, September 19, 1983.

_____ "Contemporary Indian Artwork on Display at the Woodland Centre." *The Brantford Expositor*, October 3, 1982.

Richards L. Nelson Gallery and the C.N. Gorman Gallery. *Confluences of Traditions and Change/24 American Indian Artists*. Davis, Calif.: University of California, 1981.

Richards, Tally. "Fritz Scholder: Meeting the Challenges." *Southwest Art*, May 1980, 114-119.

_____ "Indian in Paris." *American Indian Art Magazine*, Spring 1977, 48.

Ridgway, Peggi. "Harrison Begay." *Southwest Art*, June 1982, 58-63.

Roberts, Prudence I. *Northwest Viewpoints: James Lavadour*. Portland: Oregon Art Institute, July 10-September 6, 1990.

Rosenbrough, Beth. "Gallup Artist Mentioned." *Gallup Independent*, November 19, 1989.

Rubin, William, ed. "Primitivism." In *20th Century Art*. Vol. 1. New York: The Museum of Modern Art, 1984. Exhibition catalogue.

Rushing, W. Jackson. "Native American Art and Culture and the New York Avant-Garde, 1910-1950." Ph.D. diss., University of Texas, Austin, 1989.

_____ "Ritual and Myth: Native American Culture and Abstract Expressionism." In *The Spiritual in Art: Abstract Painting, 1890-1985* by Maurice Tuchman, et al. Los Angeles: Abbeville Press, Los Angeles County Museum of Art, 1985.

Sapp, Allen. *A Cree Life, The Art of Allen Sapp*. Vancouver, British Columbia, Canada: J.J. Douglas, Ltd., 1977.

Sasser, Elizabeth Skidmore. "David P. Bradley." *Southwest Art*, December 1983.

_____ "Artist Hopid." *Southwest Art*, June 1982, 76-83.

Schaafsma, Polly. *Indian Rock Art of the Southwest*. Albuquerque and Santa Fe: University of New Mexico Press and School of American Research, 1980.

Schoharie Museum of the Iroquois Indian. *Stan Hill: Iroquois Art, A Retrospective Exhibition of his Most Important Carvings from the United States and Canada*. Schoharie, N.Y.: Schoharie Museum of the Iroquois Indian, September 30-October 31, 1984. Exhibition catalogue.

_____ *Joseph Jacobs: Iroquois Art, A Retrospective Exhibit of His Carvings*. Schoharie, N.Y.: Schoharie Museum of the Iroquois Indian, September 31-October 31, 1984. Exhibition catalogue.

Scholder, Fritz. *Scholder/Indians*. Flagstaff, Ariz.: Northland Press, 1972.

_____ *Indian Kitsch: The Use and Misuse of Indian Image*. Flagstaff, Ariz.: Northland Press, 1979.

Scholder, Fritz and Clinton Adams. *Fritz Scholder, Lithographs*. Boston: New York Graphic Society, 1975.

Scholder, Fritz, Jeremy Strick and John Wilmerding. *Fritz Scholder, Painting and Monotypes*. Altadena, Calif.: Twin Palms Publishers, 1988.

Scholder, Fritz and Joshua C. Taylor. *Fritz Scholder/The Retrospective 1960-1981*. Tucson, Ariz.: Tucson Museum of Art, May 10-July 19, 1981. Exhibition catalogue.

Schrader, Robert Fay. *The Indian Arts and Crafts Board*. Albuquerque: University of New Mexico Press, 1983.

Scott, Eddie. "T.C. Cannon: 1946-1978." *Southwest Art*, June 1981, 76-79.

Scott, Jay. Changing Woman: *The Life and Art of Helen Hardin*. Flagstaff, Ariz.: Northland Press, 1989.

Seabourn, Bert D. *The Master Artists of the Five Civilized Tribes*. Oklahoma City: Bert D. Seabourn, 1978.

_____ *A Portfolio of Paintings by Bert D. Seabourn*. Oklahoma City: Indian Gallery, Inc., 1972.

Seymour, Tryntje Van Ness. *When the Rainbow Touches Down*. Phoenix: The Heard Museum, 1988. Exhibition catalogue.

Shane, Karen. "Helen Hardin 1943-1984: Casting Her Own Shadow." *Southwest Art*, June 1985, 42-47.

Siebert, Erna and Werner Forman. *North American Indian Art*. New York: Tudor, 1967.

Silberman, Arthur. *100 Years of Native American Painting*. Oklahoma City: Oklahoma Museum of Art, 1978.

_____ "Early Kiowa Art." *Oklahoma Today* 23, no. 1 (Winter 1972-1973).

Sims, Peter. *Crossed Cultures.* Documents Northwest, The Poncho Series. Seattle: Seattle Art Museum, April 13-May 28, 1989. Exhibition catalogue.

Sloan, John. "The Indian as Artist." *Survey Graphic* 67, no. 5 (1931): 243.

Sloan, John and Oliver Lafarge. *Introduction to American Indian Art.* 2 vols. New York: The Exposition of Indian Tribal Arts, Inc., 1931.

Smith, Watson. *Kiva Mural Decorations at Awatovi and Kawaik-A.* Vol. 37, Peabody Museum Papers. Cambridge, Mass.: Peabody Museum, 1952.

Snodgrass, Jeanne O. "American Indian Painting." *Southwest Art* 11 no. 1 (1969).

Snodgrass, Jeanne O., comp. *American Indian Painters: A Biographical Directory.* Contributions From the Museum of American Indian, Heye Foundation. Vol. 21, Part 1. New York: Museum of the American Indian, Heye Foundation, 1968.

Southwest Museum. *New Horizons in American Indian Art.* Los Angeles: Southwest Museum, 1976. Exhibition catalogue.

Stone, Willard. *Willard Stone: Wood Sculptor.* Muskogee, Okla.: Five Civilized Tribes Museum, 1968. Exhibition catalogue.

Strickland, Rennard, "Where Have All The Blue Deer Gone? Depth and Diversity in Post War Indian Painting." *American Indian Art Magazine* 10, no. 2 (1985).

Strickland, Rennard and Jack Gregory. "Indian Art: An Appreciation of American Heritage." *North American Indian Art.* Pensacola, Fla.: Pensacola Museum of Art, 1978.

Suleiman, Susan R. and Inge Crossman, eds. *The Reader in the Text.* Princeton, N.J.: Princeton University Press, 1980.

Tanner, Clara Lee. Southwest *Indian Painting: A Changing Art.* Tucson: University of Arizona Press, 1973.

_____ *The James T. Bialac Collection of Southwest Indian Painting.* Tucson: Arizona State Museum, University of Arizona, 1968. Exhibition catalogue.

_____ "Fred Kabotie: Hopi Indian Artist." *Arizona Highways*, July, 1951.

_____ "Contemporary Indian Art." *Arizona Highways*, February 1950, 24-29.

Tarshia, Jerome. "Dance of Coyote in Blue Jeans." *Christian Science Monitor*, Wednesday, March 2, 1988.

Thomas, D.H. *The Southwestern Indian Detours.* Phoenix: Hunter Publishing Company, 1978.

Tiger, Peggy and Molly Babcock. *The Life of Jerome Tiger, War to Peace, Death to Life.* Norman, Okla.: University of Oklahoma Press, 1980.

Torgovick, Marianna. *Gone Primitive: Savage Intellect, Modern Lives.* Chicago: University of Chicago Press, 1990.

Traugott, Joseph. "Native American Artists and the Post-Modern Cultural Divide." Paper presented at the annual meeting of the College Art Association, New York, 1990.

_____ "Emmi Whitehorse: Kin'Nah'Zin." *Artspace*, Summer 1982, 40-41.

United States Department of the Interior, Indian Arts and Crafts Board, *Sculpture by Willard Stone, An Exhibition.* Washington, D.C.: Indian Arts and Crafts Board, December 5, 1976-January 5, 1977. Exhibition catalogue.

_____ *Paintings by Blackbear Bosin.* Washington, D.C.: Indian Arts and Crafts Board, August 8-September 30, 1976. Exhibition catalogue.

_____ *Native American Arts.* Washington, D.C.: Indian Arts and Crafts Board, 1968. Exhibition catalogue.

_____ *Indian Art in the United States and Alaska: A Pictorial Record of the Indian Exhibition at the Golden Gate International Exposition.* Washington, D.C.: Indian Arts and Crafts Board, 1939. Exhibition catalogue.

United States Department of State and International Communications Agency. *Pintura Amerindia Contemporanea/E.U.A.* Washington, D.C.: United States Department of State and International Communications Agency, 1979.

United States of the Interior Art Gallery. *Annual Invitational Exhibitions of American Indian Painting.* Washington, D.C.: United States of the Interior Art Gallery, 1965-1969. Exhibition catalogue.

Velarde, Pablita. *Old Father, The Story Teller.* Globe, Ariz.: Dale Stuart King, 1960.

Wade, Edwin L. "What is Native American Art?" *Southwest Art*, October 1986, 108-117.

Wade, Edwin L., ed. *The Arts of the North American Indian, Native Traditions in Evolution.* New York: Hudson Hills Press in association with the Philbrook Art Center, Tulsa, Okla., 1986.

Wade, Edwin L. and Rennard Strickland. *Magic Images Contemporary Native American Art.* Norman, Okla.: University of Oklahoma Press with the Philbrook Art Center, Tulsa, Okla., 1981.

Wagner, Sallie R., J.J. Brody, and Beatien Yazz. *Yazz: Navajo Painter.* Flagstaff, Ariz.: Northland Press with the School of American Research, 1983.

Wallo, William and John Pickard. *T.C. Cannon, Native American: A New View of the West.* Oklahoma City: National Cowboy Hall of Fame, 1990. Exhibition catalogue.

Wardell, A. *Objects of Bright Pride.* New York: American Federation of Arts and Centre for Inter-American Relations, 1978. Exhibition catalogue.

Warner, John A. "Contemporary Graphics of the Northwest Coast." *Four Winds* (Autumn 1980): 22-30.

_____ "Allen Sapp, Cree Painter." *American Indian Art Magazine* 2, no. 1 (1976): 40-45.

Washburn, Dorothy K., ed. *The Elkus Collection. Southwestern Indian Art.* San Francisco: The California Academy of Sciences, 1984.

Wasserman, Abby. "Jim Schoppert." *Native Vision* (American Indian Contemporary Arts Gallery, San Francisco) 3, no. 1 (February/March 1986): 8-9.

Water, Fresh. "We are the Seventh Generation: A New Generation of Continued Indian Art Challenges Us to Re-Think our Image of the Indian." *The Indian Reader* (Spring 1986): 2.

Wheelwright Museum of the American Indian. *Merging and Emergence, An Exhibition of Works by the Artists on the Faculty of the Institute of American Indian Art.* Santa Fe, N.Mex.: Wheelwright Museum of the American Indian, 1988. Exhibition catalogue.

Wilks, Flo. "Helen Hardin." *Southwest Art*, August, 66-69.

Williams, Neva. *Patrick DesJarlait: The Story of An Indian Artist.* Minneapolis: Lerner Publications Co., 1975.

Wilson, Wendy. "Years of Protest at the Institute of American Indian Art, Santa Fe." *Artspace* (June 1980).

_____ "T.C. Cannon: A Retrospective." *Artspace*, (Winter 1980).

Yorba, Johnathan. *Drawn from the Surroundings: The Elkus Collection of Eskimo Paintings.* San Francisco: A.S. Graphics, San Francisco State University, 1990.

Zepp, Norman and Michael Parke-Taylor. *Horses Fly Too.* Regina, Saskatchewan, Canada: Norman MacKenzie Art Gallery, University of Regina, 1984. Exhibition catalogue.

The Heard Museum wishes to acknowledge the support and vision of the following people and institutions:

The artists: past, present, and future.

Burton Benedict, Ph.D., Director, Lowie Museum of Anthropology, University of California, Berkeley, California

Chuck Cecil and Russel Hartman, Department of Anthropology, California Academy of Sciences, San Francisco, California

Phyllis M. Cohen, Librarian, and Diane Block, Curator of Collections, Museum of Fine Art, Museum of New Mexico, Santa Fe, New Mexico

Chuck Daley, Instructor of Museum Studies, and Verna Solomon, Registrar, Institute of American Indian Art Museum, Santa Fe, New Mexico

Stella Desarego, Photo-archivist, Special Collections, University of New Mexico Library, University of New Mexico, Albuquerque, New Mexico

Rowena Dickerson, Santa Fe, New Mexico

Michael J. Fox, Director/CAO, Behring Educational Institute, Inc., Danville, California, and former Director, The Heard Museum, Phoenix, Arizona

Victor Grant, Archivist, Kit Carson Foundation, Taos, New Mexico

Jack Gregory, Phoenix Union School District, Phoenix, Arizona

Sara Hawkins, The National Archives, Washington, D.C.

Nina S.I. Jacobson, Curator, State Museum of History, Oklahoma Historical Society, Oklahoma City, Oklahoma

Ray Miles, Librarian, and Pam Tijerina, Student Assistant, University Libraries, Western History Collections, University of Oklahoma, Norman, Oklahoma

Anne Hodges Morgan, President, Robert S. & Grayce B. Kerr Foundation, Oklahoma City, Oklahoma.

H. Wayne Morgan, Ph.D., Cross Research Professor of History, University of Oklahoma, Norman, Oklahoma

Jo Nast, Education Director, University Museum, Southern Illinois University, Carbondale, Illinois

Anneret Ogden, Librarian, Bancroft Library, University of California, Berkeley, California

Janis Pratt-Young, Administrative Assistant, American Indian Law Center, University of Oklahoma, Norman, Oklahoma

Herb Puffer, Western Pacific Traders, Folsom, California

Mary Purdy, Assistant Registrar, National Museum of the American Indian, Smithsonian Institution, New York, New York

Pat Reck, Curator, Indian Pueblo Culture Center, Albuquerque, New Mexico

Paula Rivera, Assistant Curator, Laboratory of Anthropology, Museum of Indian Arts and Culture, Museum of New Mexico, Santa Fe, New Mexico

Steve Rogers, Curator, Wheelwright Museum of the American Indian, Santa Fe, New Mexico

School of American Research, Santa Fe, New Mexico

Barbara Seisenhart, Five Civilized Tribes Museum, Muskogee, Oklahoma

Jeanne Snodgrass-King, Tulsa, Oklahoma

Geoffrey Stamm and Robert Hart, Indian Arts and Crafts Board, United States Department of the Interior, Washington, D.C.

Linda Stone Laws, Curator, The Woolaroc Museum, Bartlesville, Oklahoma

David Swank, Dean, College of Law, University of Oklahoma, Norman, Oklahoma

Jonathan Thompson Velie, Research Assistant, University of Oklahoma, Norman, Oklahoma

Edwin L. Wade, Ph.D., Curator of Art, The Philbrook Art Center, Tulsa, Oklahoma

Johnathan Yorba, San Francisco, California

Thomas Young, Librarian, The Philbrook Art Center, Tulsa, Oklahoma

LENDERS AND SPONSORS

INSTITUTIONAL LENDERS

California Academy of Sciences
Golden Gate Park
San Francisco, California

The Denver Art Museum
Denver, Colorado

The Thomas Gilcrease Institute
of American History and Art
Tulsa, Oklahoma

The Hood Museum
Dartmouth College
Hanover, New Hampshire

Indian Arts and Crafts Board
U. S. Department of the Interior
Washington, D.C.

Institute of American Indian Art
Museum
Santa Fe, New Mexico

Museum of Fine Art
Museum of New Mexico
Santa Fe, New Mexico

Museum of American Indian Arts and
Cultures
Museum of New Mexico
Santa Fe, New Mexico

National Museum of the American Indian
Smithsonian Institution
The U.S. Custom House
New York, New York

The Oklahoma Historical Society
Oklahoma City, Oklahoma

Oklahoma University Art Museum
University of Oklahoma
Norman, Oklahoma

The Philbrook Art Center
Tulsa, Oklahoma

School of American Research
Santa Fe, New Mexico

University Art Museum
University of Minnesota
Minneapolis, Minnesota

INDIVIDUAL LENDERS

Mr. James T. Bialac

Mr. and Mrs. R.C. "Dick" Cline

Mr. Richard Danay

Albion and Lynne Fenderson

Mr. Harry Fonseca

Mr. and Mrs. Henry Galbraith

Mr. Robert Haozous

Mr. G. Peter Jemison

Mr. Frank LaPena

Mr. James Lavadour

Mr. James Luna

Mr. George Morrison

Mr. and Mrs. H.C. Puffer

Dr. Rennard Strickland

Ms. Hulleah Tsinhnahjinnie

Ms. Kay WalkingStick

Anonymous

SPONSORS

The Flinn Foundation
Phoenix, Arizona

AT&T
New York, New York

Gallery 10
Scottsdale, Arizona

Edna Rider Whiteman Foundation
Phoenix, Arizona

AG Communications Systems
Phoenix, Arizona

KTSP-TV 10/CBS
Phoenix, Arizona

110